THE NATIONAL GALLERY SCHOOLS OF PAINTING

French Paintings before 1800

THE NATIONAL GALLERY SCHOOLS OF PAINTING

French Paintings before 1800

MICHAEL WILSON

Deputy Keeper,
The National Gallery

The National Gallery, London
in association with William Collins 1985

William Collins Sons and Co Ltd
London · Glasgow · Sydney · Auckland
Toronto · Johannesburg

BRITISH LIBRARY CATALOGUING IN PUBLICATION DATA

Wilson, Michael, 1951–
 French paintings before 1800.—
 (The National Gallery schools of painting)
 1. Painting, French
 I. Title II. Series
 759.4 ND546

ISBN 0 00 217406 5

Photoset in Imprint by Ace Filmsetting Ltd, Frome
Colour reproductions by P. J. Graphics Ltd, London W3
Made and printed by Staples Printers Kettering Ltd.

The front cover shows Lancret's *A Lady and Gentleman
taking coffee with Children in a Garden*; the back cover shows
a detail from Claude's *Seaport with the Embarkation of the
Queen of Sheba*.

THE NATIONAL GALLERY SCHOOLS OF PAINTING

This series, published by William Collins in association with the National Gallery, offers the general reader an illustrated guide to all the principal schools of painting represented in the Gallery. Each volume contains fifty colour plates with a commentary and short introduction by a member of the Gallery staff. The first six volumes in the series are:

Dutch Paintings by Christopher Brown
French Paintings before 1800 by Michael Wilson
Spanish and Later Italian Paintings by Michael Helston
Italian Paintings of the Sixteenth Century by Allan Braham
Early Netherlandish and German Paintings by Alistair Smith
French Paintings after 1800 by Michael Wilson

Further volumes completing the series will be published in 1985.

French Paintings before 1800

By comparison with nineteenth-century French painting (the subject of another volume in this series, *French Paintings after 1800*), earlier French art is both less well known and less widely appreciated in England. Yet as this book shows, there are great French paintings of the seventeenth and eighteenth centuries in the National Gallery which are no less appealing and delicately handled than the famous works of the Impressionists. Claude's romantic landscapes, (*The Enchanted Castle* and *Hagar and the Angel* among them), Watteau's magical parklands and the charming heroines of Boucher, Nattier and Fragonard are irresistibly attractive to anyone who takes the time to look at them.

The period of French art covered in this book is also extraordinarily diverse. In marked contrast to the grand portraiture of

Philippe de Champaigne, Mignard and Rigaud are the genre paintings of the Le Nain brothers, which respectfully depict pious peasant families, and the direct and truthful portraits of Perronneau and La Tour. After Poussin's serious and often sombre re-creations of classical antiquity come light-hearted and brightly-coloured mythologies by the rococo painters of the eighteenth century. And in surprising contrast to them we find a contemporary, Chardin, producing sober pictures of bourgeois people drawn from real life.

This volume provides an ideal introduction to the paintings of this rich and complex period, and will be useful both as a guide in the Gallery and, given the excellence of the plates, as a work of reference away from it. In either case, Michael Wilson's lucid and stimulating commentary on the paintings will greatly help the reader in coming to know them.

MICHAEL WILSON has worked at the National Gallery since 1975 and is Deputy Keeper in charge of French Paintings. Among his publications are *Nature and Imagination, the Work of Odilon Redon* (Phaidon 1978), *The Impressionists* (Phaidon 1983) and books on the National Gallery, including another volume in this series, *French Paintings after 1800*.

THE NATIONAL GALLERY SCHOOLS OF PAINTING

French Paintings before 1800

Introduction

Like all great picture collections, the National Gallery has its own individual character, its own strengths and weaknesses, and its outstanding highlights – paintings such as Piero della Francesca's *Baptism* and van Eyck's *Arnolfini Marriage*, for example. It is not, and never will be, a perfectly balanced representation of every major school and every major artist, and it probably owes its special character to the fact that it is no such compendious and flawless entity.

Undoubtedly the great strengths of the National Gallery are its Italian and Dutch paintings, reflecting as they do the high esteem in which they were held in the nineteenth century when the Gallery was in its infancy, and the great efforts and great sums that were expended on their acquisition. The representation of the French School is, in marked contrast, erratic. There is a remarkable group of seventeenth-century paintings by Claude, Poussin and Gaspard Dughet – a large number of which are illustrated in this book – but, with the exception of these, French painting has, until recent years, been poorly represented. The Lane Bequest in 1917 and the creation of the Courtauld Fund in 1923 laid the foundation of the Impressionist collection, but the eighteenth century continued to be neglected. A spate of energetic and imaginative acquisitions has in the last ten years transformed this part of the collection. Nevertheless, while the seventeenth-century Dutch paintings, for example, require eight main floor rooms, the eighteenth-century French pictures are accommodated in one moderately sized gallery (fig. 1).

It is only necessary to contrast the National Gallery paintings with the French eighteenth-century holdings of the Wallace Collection at Hertford House to appreciate the relative weakness in this school. Against the National Gallery's one small Watteau (Plate 29), the Wallace Collection has eight fine examples; against one early Fragonard (Plate 40), it has ten paintings of various types and periods; and against two small Bouchers (Plates 38 and 39) it has no less than twenty-two canvases, including the enormous *Rising* and *Setting of the Sun*. The presence of the Wallace Collection nearby has, of course, played its part in the neglect of French art at Trafalgar Square. How to begin to match the riches of the Wallace, has been the question; better not to try, has been the answer. However, recent purchases, such as the full-length *Portrait of Madame de Pompadour* by Drouais (Plate 46), the Fragonard *Psyche and her Sisters* (Plate 40) and the pair of hunts by Parrocel (Plate 28), show how major acquisitions of widely varying type can

be made in this field without duplicating the holdings of the Wallace Collection.

There are, of course, historical reasons for the unbalanced character of the French collection and for its neglect. First amongst them is an almost traditional suspicion of the British for things French. To the fear of Catholicism, the English had to add, after 1793, the horror of regicide. Only a handful of outstanding collections of earlier French art exist in England, notably the Wallace Collection, the Bowes Museum, and the Rothschild collection at Waddesdon, all of them formed by men with strong ties with France. English collectors otherwise generally considered French art to be frivolous and immoral, and (excepting the seventeenth-century painters already mentioned) ignored it. Consequently few great French paintings have come to the Gallery by gift or bequest. The same attitudes were held by those who administered the Gallery in the nineteenth century, and thus few purchases were made in this field. The Treasury Minute of 1855, following the inquiry into the affairs of the National Gallery in 1853, recommended that priority should be given to 'good specimens of the Italian Schools, including those of the earlier masters', and this is

A view of the French eighteenth-century paintings as displayed in Room 33.

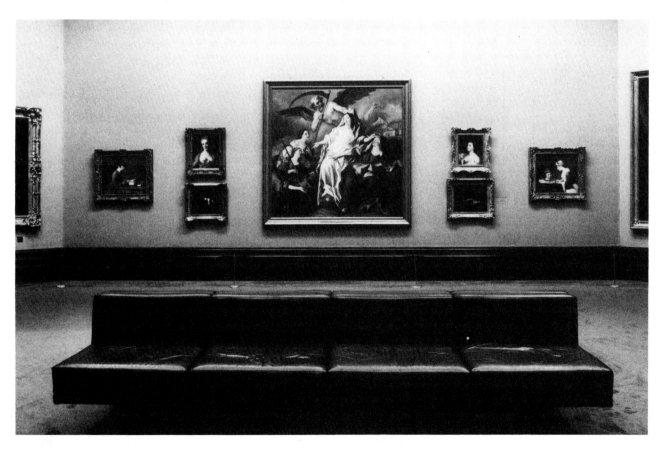

precisely what Sir Charles Eastlake, the first Director of the Gallery, proceeded to do, travelling to Italy each year and returning with such masterpieces as the Pollaiuolo *S. Sebastian* altarpiece, Veronese's *Family of Darius before Alexander*, Uccello's *Battle of San Romano* and Piero's *Baptism*. In marked contrast, Eastlake seems to have had little more than contempt for French painting. 'A crying defect in all French painters,' he wrote, 'though perhaps not so much their fault as their country's, is that *goût libre* which is such a terrible abuse of the art.'

For such purposes, however, one can exclude from the category of French painters the seventeenth-century landscapists – Claude, Poussin and Gaspard Dughet – who made amends, as it were, for their French origins by living in Rome and steeping themselves in antiquity. Their works were learned and serious, treating for the most part subjects derived from classical history and mythology or the Bible. Furthermore, they displayed a knowledge and love of nature pleasing to English landowners.

For these reasons paintings by Poussin, Claude and their followers were avidly collected by English visitors to Rome in the eighteenth century. One of the effects, if not indeed one of the purposes, of the Grand Tour was for English gentlemen to acquire works of art to furnish their homes, themselves built in an Italianate manner, and set in landscaped parks often based on the paintings of Claude and Dughet, and suggestive of classical antiquity. Consequently, by the end of the eighteenth century fine examples of such works could be found in aristocratic collections throughout Britain. And it is no coincidence that they are amongst the earliest items to enter the National Gallery.

A watercolour by Frederick MacKenzie shows the interior of the National Gallery as it appeared in 1834 (fig. 2), when it was only ten years old. The Gallery was founded in 1824 when Lord Liverpool's government voted £60,000 for the purchase of the collection of the recently deceased financier, John Julius Angerstein, together with the lease of his house, where the paintings, together with others subsequently acquired for the nation, were housed until 1834. Among the thirty-eight Angerstein paintings were no less than five Claudes, three of which can be seen in MacKenzie's painting: *Cephalus and Procris reunited by Diana* and *The Embarkation of Saint Ursula* to the left of Sebastiano's enormous *Raising of Lazarus*, and the *Seaport* (Plate 16) to the right of it. The two that are not visible are the great 'Bouillon' Claudes (Plates 18 and 19) which Angerstein had purchased in 1803. Among the Angerstein paintings were also two Gaspard Dughets, one of which, *A Storm*, is shown at the top on the left of the watercolour, and an old copy of a Poussin. To these pictures were added in 1826 Sir George Beaumont's Gift, which included three Claudes, one of which, *The Death of Procris* (now considered an old copy), is visible in the further room in the bottom tier. A fourth Claude,

Hagar and the Angel (Plate 17), only came to the Gallery in 1828 after Beaumont's death, since he could not bear to part with it. He also gave a Poussin landscape and the Bourdon *Return of the Ark* (Plate 23) which had been bequeathed to him by Sir Joshua Reynolds, whose favourite painting it is supposed to have been. Also in 1826, the Treasury purchased, along with Titian's *Bacchus and Ariadne*, Poussin's *Bacchanalian Revel* (Plate 3), both of which can be seen in MacKenzie's watercolour. In 1831 the Reverend Holwell Carr's bequest of paintings joined the collection, and included the 'Chigi' Claude (Plate 20), a copy of Poussin and three Gaspard Dughet landscapes. Among Lord Farnborough's bequest in 1838 was one Dughet, the superb, late *Tivoli* (Plate 25).

Thus, in the early years of the Gallery's existence, seventeenth-century Roman landscapes made up a considerable part of the collection. Within five years of its foundation, ten of the Gallery's thirteen Claudes had already been acquired – exceeding in number the works of any artist in the collection.

This astonishing statistic cannot but have had its effect on painting in England. One of the principal purposes underlying the creation of the National Gallery was to provide good examples for young artists, to nourish, as it were, the British School. The landscape tradition established in the eighteenth century was based on the example of Claude and Dughet. Apart from the proliferation of prints after their works, their paintings could be seen by application in private collections, and after 1824 were readily accessible at the National Gallery. The roles of collector and patron were combined in the person of Sir George Beaumont (fig. 3). A painter himself, and an enthusiast for landscape painting, he encouraged young artists, including Constable, and made his precious Claudes available to be copied. (Constable's copy of Claude's *Goatherd with Goats*, which belonged to Beaumont, is in the Art Gallery of New South Wales.)

Richard Wilson and Turner both formed their landscape art on the example, above all, of Claude, and both painted pastiches of his works. Turner's imitations, however, were more than mere emulation. He wished to show that he could out-do Claude in all the natural effects in which he excelled – and in Ruskin's view he succeeded. When he died, bequeathing his life's work to the National Gallery, his will specified that two of his canvases, *Sun rising through Vapour* and *Dido building Carthage* (fig. 4), should hang between the 'Bouillon' Claudes, paintings which Turner had studied and admired in the National Gallery, and previously in Angerstein's collection. *Dido building Carthage* is a seaport composition in the manner of *The Embarkation of the Queen of Sheba* (Plate 19). Both paintings feature celebrated queens of antiquity and the ancient cities they governed, and in both the sun is shown reflected spectacularly in the sea. But at that point all resemblance ceases. Claude's painting is a model of classical harmony and pro-

portion. In Turner's all Claude's architectural and natural effects are exaggerated; buildings and landscape are of a colossal scale. Carthage appears to be in ruin rather than in construction, and the mood of the painting is replete with intimations of doom and disaster.

French classical landscapes left their mark elsewhere also in England, on the landscape gardens created in the eighteenth century and on poetry. References to Claude, Poussin and Dughet abound in such works as Thomson's *Seasons*, poetry which aspires to imitate the pictorial effects of these artists. More distinguished use of Claude was made by John Keats. He was familiar with *The Enchanted Castle* (Plate 21), at least through Woollett's famous engraving, and in 1818 wrote a long verse account of it in a letter to a friend in which he responds to Claude's image with all manner of fanciful and magical associations. Keats may well have seen the painting itself when it was shown at the British Institution in 1819,

Frederick MacKenzie (c. 1787–1854). The interior of 100 Pall Mall, the home of the National Gallery from 1824 to 1834, as it appeared in 1834. *Watercolour. The Victoria and Albert Museum.*

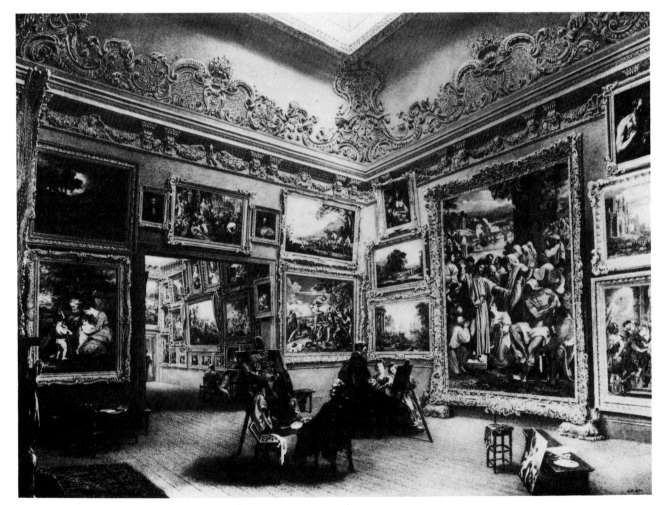

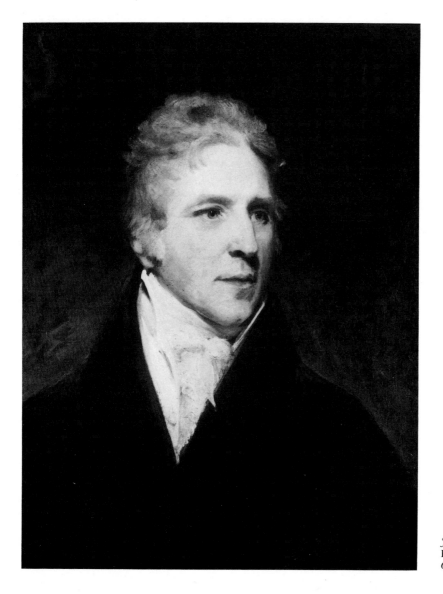

John Hoppner (1758?–1810). Sir George Beaumont *c. 1806. Oil on canvas. The National Gallery.*

and it seems that the image of 'magic casements, opening on the foam/Of perilous seas in faery lands forlorn' in the 'Ode to a Nightingale' is prompted by his memory of Claude's painting, with its mysterious castle overlooking the sea.

In marked contrast, however, to this enthusiasm for Claude and his fellow landscape painters is the neglect by collectors, artists and writers of other French painters of the seventeenth century and, in particular, of the eighteenth century. There are some rare exceptions. Eustache Le Sueur, for example, was considered by Walpole to be the equal of the great Italian masters of the sixteenth century. Of his *Saint Bruno* series Walpole wrote, 'in simplicity and harmony, it beats Raphael himself'.

One French painter of the eighteenth century who found favour with the English was Claude-Joseph Vernet. He married an Irish wife in 1745, and through her came in contact in Rome with a variety of English patrons. Vernet is also rare in being one of the few French painters of his century to have made an impression on English artists, many of whom met him in Rome. Like the portraits of Batoni, and Panini's pictures of Roman ruins, Vernet's landscapes were bought as souvenirs of the Grand Tour. No doubt they benefited in this respect in being derived from the seventeenth-century landscape painters so much admired by English collectors. Examples of Vernet's work entered the National Gallery at a fairly early date, the *Sea-Shore* (Plate 48) in 1846/47 and two more paintings in 1853 and 1879.

French eighteenth-century paintings gradually entered the collection, almost, as it were, by default. No attempt was made to buy them but they were occasionally given or bequeathed by collectors. As early as 1836/7 four Lancrets, *The Ages of Man*, were left to the Gallery by Lt-Col. J. H. Ollney. The important Wynn Ellis Bequest of 1876 included two small works by Greuze (Plate 44) as well as a late Claude (Plate 22). Mrs Robert Hollond, whose portrait by Ary Scheffer (fig. 5) was bequeathed by her husband, the Member of Parliament for Hastings, in 1877, herself presented the Boucher *Pan and Syrinx* (Plate 39) in 1880. She was a noted authoress and philanthropist and held a *salon* in Paris which attracted the leading Liberals of the day. In 1912 Sir Julius Wernher bequeathed his Watteau (Plate 29) and in 1914 Sir John Murray Scott, adviser to Sir Richard and Lady Wallace, left several French paintings comprising a Watteau copy, four Horace Vernet battle paintings and the full-length *Portrait of the Marquise de Seignelay with her Children* by Mignard (Plate 27). Another important bequest of French paintings was that made in 1945 by Miss Emilie Yznaga, sister of the Duchess of Manchester, who left a group of eighteenth-century portraits by Largillière, Roslin, Tocqué, Greuze and Nattier, including the charming *Manon Balletti* (Plate 41). More recently, Lancret's masterpiece, *A Lady and Gentleman with Two Girls in a Garden* (Plate 34), was bequeathed to the Gallery by Sir John Heathcoat Amory, Bart, with a life interest to his wife, who generously renounced it, allowing the painting to enter the collection in 1973.

Without the generosity of such benefactors, the Gallery would have had no eighteenth-century collection. No attempt was made to build on the gifts of others, to construct a representation worthy of the collection by buying important works as they became available, until very recently. Of the paintings illustrated in this book, ten have been purchased in the last decade, and of these only two, Claude's *The Enchanted Castle* (Plate 21) and Poussin's *The Triumph of Pan* (Plate 4) are of the seventeenth century (unless one also includes the unusual pair of hunts by Parrocel (Plate 28)

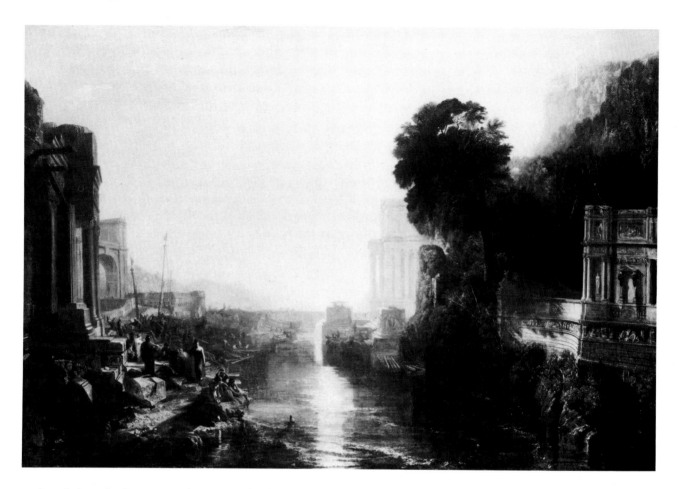

J. M. W. Turner (1775–1851). Dido building Carthage *1815. Oil on canvas. The National Gallery.*

painted just before 1700 but already in an eighteenth-century idiom).

The portraits by Rigaud, Perronneau and Drouais (Plates 30, 43 and 46) are each in their way superb examples of the genre. The *Portrait of Madame de Pompadour* is probably Drouais' masterpiece; certainly it is a work of great historical importance and was purchased privately by the Gallery from the Rosebery Collection at Mentmore Towers at the time of the famous Mentmore sale in May 1977. Among the works of art at Mentmore were many French items, including one large and discoloured canvas, hung high above the main staircase, which was catalogued as a Carle Van Loo. It was purchased by the late Mr David Carritt, who restored it and proved it to be a lost Fragonard (Plate 40). Subsequently it was bought by the Gallery, and as the only large-scale French subject painting of its period in the collection it has become one of its chief highlights. Two other recent purchases, of paintings by Detroy (Plate 31) and Taillasson (Plate 50), provide examples of history painting early and late in the century and create a fascinating context for the Fragonard.

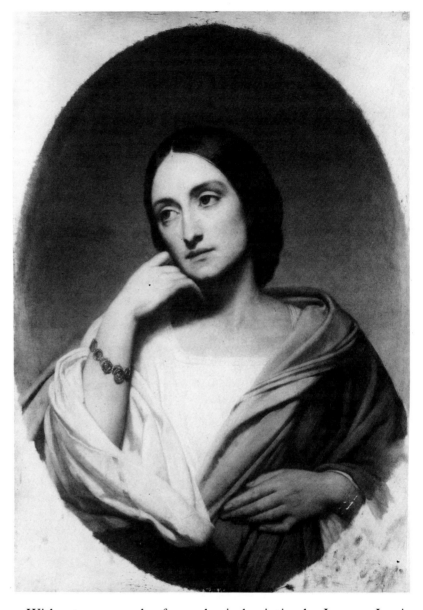

Without an example of neo-classical painting by Jacques-Louis David, the greatest painter of his age, the Taillasson must serve to represent the moment when the rococo was rejected in favour of antique themes and an austere, classical style derived from Poussin, an artist fortunately well represented in the Gallery. Thus at the end of the period illustrated by this book the art of painting performs one of those remarkable *volte-faces*, whereby artists return to earlier examples to reinvigorate their art. What consequences this had for the painting of the nineteenth century in the work of Ingres and Delacroix and their successors is the subject of another volume in this series, *French Paintings after 1800*.

PLATE 1

Le Valentin, 1591–1632

The Four Ages of Man (No. 4919)

Canvas, 96.5 × 134 cm.

Presented by Viscount Bearsted through the N.A.-C.F., 1938

For French painters at the beginning of the seventeenth century, serious study necessarily entailed directing their attention to Italian art and, if circumstances allowed, going to live and work in Rome, the artistic capital of the world. There was no national school in France at the time worthy of the name. The great painters of the Fontainebleau school had been summoned from Italy, and it was the great achievements of Italian painting in the sixteenth century that drew French painters to Rome. Like Poussin and Claude, Le Valentin, who came from Coulommiers in Brie, went as a young man to Rome and died there.

In Rome, Le Valentin was one of the generation of Italians and foreigners who fell under the irresistible influence of Caravaggio, and he is one of the most talented of Caravaggio's followers. In his works one finds the characteristic brand of naturalism of the Caravaggisti: large-scale figures in contemporary dress depicted with scrupulous attention to detail, and illuminated by a harsh sidelight which reveals every crease of skin and every fold of fabric, which gleams on metal, glints on glass and casts sonorous black shadows, out of which the figures seem to emerge with all the intensity of living beings.

This painting dates from about 1626, and seems to have been cut down, especially along the bottom. The subject is allegorical; the four figures represent childhood, youth, maturity and old age. By grouping them together, Le Valentin points out the frailty of human existence, how, with the passage of time, youth must inevitably lead to old age and to death. This theme is reinforced by the occupations of the four protagonists. The boy, who is carefree and innocent, holds an open cage from which the bird, symbol of himself, has flown for ever. The youth on the left, whose intense gaze and flamboyant costume are signs of his passionate and romantic nature, plays a lute, the strains of which will die and fade. Meanwhile in the soldier, the man of maturity, and the old man who gloats over his pile of gold are represented the vanity of military glory and of riches.

The *vanitas*, as such a picture is known, and the theme of the four ages of man, are common in painting in the sixteenth and seventeenth centuries. But Le Valentin's brand of naturalism invests his symbolism with an unusual urgency. The detachment of his four subjects, one from the other, their absorption in their own ill-fated destinies, and the sombre tone of the painting create a powerful impression of gloom and melancholy.

PLATE 2

Lubin Baugin, *c.* 1610–1663

The Holy Family with S. Elizabeth, S. John and Angels (No. 2293)

Wood, 31.5 × 22.5 cm.
Bequeathed by George Fielder, 1908

Very little is known about Lubin Baugin and his works are relatively rare. He was born in Pithiviers, and in 1629 was received into the corporation of painters of Saint-Germain-des-Prés in Paris. It is very likely that after 1636 he spent some years in Italy. Certainly his very idiosyncratic art was, like Le Valentin's, moulded by Italian painting. Yet it is difficult to imagine how their work could be more dissimilar. Where Le Valentin's canvases are large with life-sized figures, Baugin's are mostly no more than a foot or so high; where the one artist uses sombre colours and deep shadows, the other chooses bright, clear, jewel-like colours; and where Le Valentin depicts his subjects with forceful, even brutal naturalism Baugin's elegant and refined figures are not made of flesh and blood at all and inhabit an idealized world.

Baugin was of a later generation than Le Valentin, and by the time he made contact with Italian art the influence of Caravaggio had waned. Amongst living artists he responded most to Guido Reni, whose sentiment he shares, but more significant for him was the example of earlier painters, of Raphael, Correggio and Parmigianino.

In this little painting, so typical of his work both in subject and treatment, the stylized landscape with its attenuated trees stems from sixteenth-century Italian painting and in particular from Raphael. The grouping of the figures also owes something to Raphael, but the soft *sfumato* of the modelling recalls Correggio, and the sinuous poses and sharp, mannerist colouring show a debt to Parmigianino. Baugin was probably familiar with Italian mannerist painting in the work of the Fontainebleau school, particularly of Rosso and Primaticcio. But the scale and delicacy of his works indicate a close acquaintance with a wide range of earlier Italian painting, which he can hardly have acquired without a prolonged stay in Italy.

Recent cleaning has uncovered the extraordinarily intense colouring of this gem-like picture in all its freshness. It also revealed how Baugin changed the positions of several of the heads, particularly that of S. Joseph. His aim has been not to render the scene as it might actually have happened, but to create a tightly interlocking design in which the bowed heads and arching wings incline towards the infant Jesus, expressive at once of tenderness and devotion.

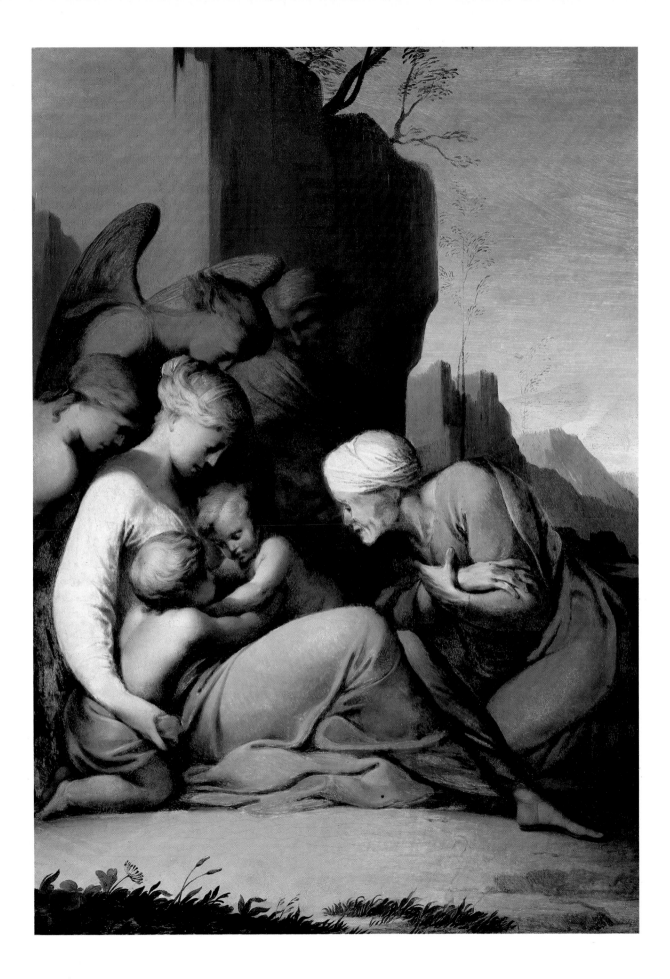

PLATE 3

Nicolas Poussin, 1594(?)–1665

A Bacchanalian Revel before a Term of Pan (No. 62)

Canvas, 100 × 142.5 cm.
Purchased 1826

Few would dispute that Poussin is the greatest French painter of his century. A highly intellectual man, he constantly sought to develop and expand his art, treating old themes in new ways, pursuing his own style independently of fashion, and thereby exercising a pervasive influence on painting well into the nineteenth century. Paradoxically, however, Poussin, like his friend Claude, spent most of his working life outside France. He arrived in Rome in 1624 at the age of thirty and, with the exception of a brief period in Paris in 1641–42, never left Italy. The whole foundation of his art is to be found in Italy, in the art and literature of ancient Rome, and in the great achievements of the High Renaissance.

This bacchanalian scene, which probably dates from the first half of the 1630s, is a work of transition, and shows Poussin moving from his early romantic manner, derived for the most part from Venetian painting, towards a more personal, classical style. The landscape, with its richly varied foliage broken by sunlight and shadow, its sweeping diagonal bough entwined with vines, and its distant glimpse of mysterious blue mountains, is the last of its kind in Poussin's work. Titian's *poesie* and particularly the *Bacchus and Ariadne*, which by coincidence entered the National Gallery in 1826 together with Poussin's *Bacchanalian Revel*, is here the source and inspiration.

But Poussin was not content merely to imitate his great Italian predecessors. His ambition was to evoke a more authentic picture of the classical past, and his dancers are carefully arranged like figures in a frieze. Before arriving at a definite design, he studied antique sculpture and Renaissance engravings of dancers, and plotted the figures and the intervals between them in large-scale drawings.

In the painting the dancers and draperies have all the solidity of sculpture, and the colour is clear and sharp. But all this is achieved without loss of gaiety or spontaneity. The complex chain of interweaving dancers unfolds effortlessly across the canvas. The art is dissembled and a lasting harmony is achieved.

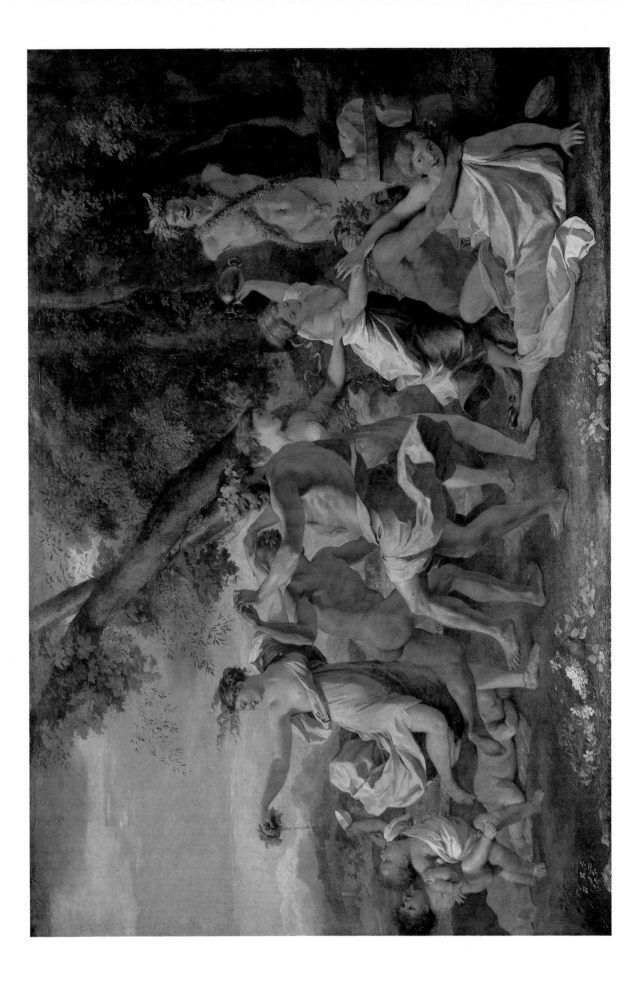

PLATE 4

Nicolas Poussin, 1594(?)–1665

The Triumph of Pan (No. 6477)

Canvas, 134 × 145 cm.
Purchased 1982

Painted only a few years later than *The Bacchanalian Revel* (Plate 3), this picture, with its taut, centralized design, crisp modelling and brilliant colour, shows Poussin at his most individual, striving to create a new classical mode appropriate to his pagan subject-matter.

With its companion, *The Triumph of Bacchus* (Nelson Gallery, Atkins Museum, Kansas City), it was painted for Cardinal Richelieu to form part of the decoration of the Cabinet du Roi in the Château de Richelieu at Poitiers. They were despatched from Rome in May 1636, accompanied by the Bishop of Albi, who, having completed his task, wrote to Richelieu that he had seen the paintings of 'Monsieur de Mantoue, which, although good, do not begin to compare with the beauty and the perfection of those that I brought with me'.

The pictures to which he refers were gifts to Richelieu from the Duke of Mantua and comprised celebrated allegorical paintings by Mantegna, Costa and Perugino from the Studiolo of Isabella d'Este in Mantua. Poussin's two paintings were commissioned to hang with these Renaissance masterpieces in the Château de Richelieu. A third painting by Poussin, a *Triumph of Silenus*, was later added to the group but is today only known in an old copy (fortuitously in the National Gallery also).

As might be expected with such an important commission, Poussin took great pains over *The Triumph of Pan*. A whole series of drawings show how he laboured over the composition, which derives from an engraving after Giulio Romano,

while the beauty of the handling testifies to the care of execution. He also aimed for great archaeological accuracy in his treatment of the subject – a band of revellers adorning a statue of Pan (or possibly Priapus, the god of gardens and fertility). Details such as the masks, the baskets of flowers, and the pipes and bent stick of Pan are derived from the accounts of classical authors and the representation of similar rites on ancient vases and sarcophagi. In his arrangement Poussin has imitated the flat, frieze-like effects of classical bas-reliefs, concentrating all the frenzied activity within a narrow strip of foreground. The composition is centralized, with the revellers gathered in a tightly knit group around the statue of Pan. They are not individualized, but exist only to participate in this ceremonial dance, which is both an exuberant display of erotic energy and a celebration of fertility.

Yet in his deliberate sacrifice of naturalism to elaborate artifice, Poussin was not only thinking of antique prototypes. He now rejected the atmospheric effects and ample modelling of Titian and his own contemporaries in Rome in order to re-create the stern classicism of Mantegna. The flat, stage-like setting, bright local colour and crystalline figures of *The Triumph of Pan* correspond exactly to the *quattrocento* idiom of Mantegna's *Parnassus*, near which it was to hang. For his contemporaries, Poussin's painting must have seemed like a reversion to primitivism, but it nevertheless established the basis of the style which was to serve him for the rest of his career.

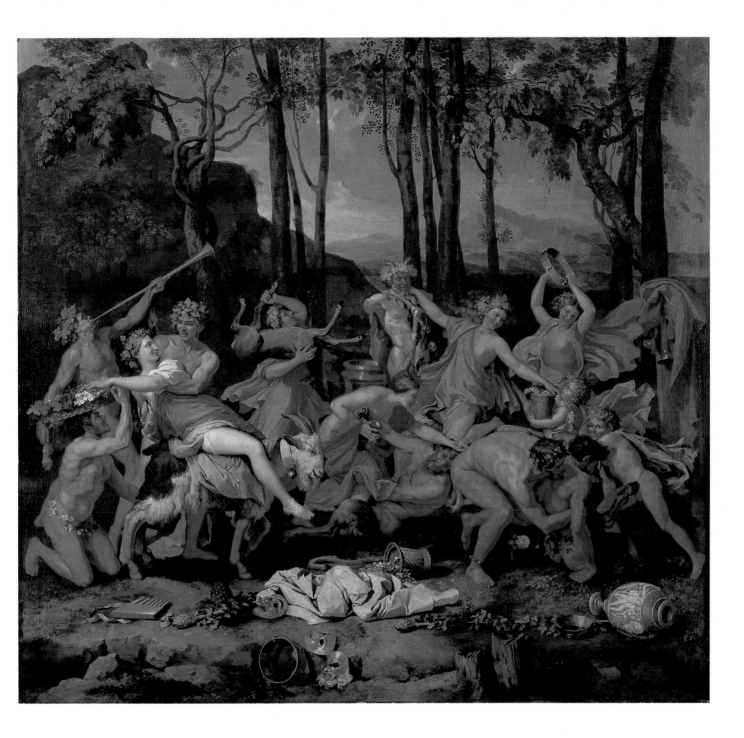

PLATE 5

Nicolas Poussin, 1594(?)–1665

The Adoration of the Golden Calf (No. 5597)

Canvas, 154 × 214 cm.

Purchased 1945

According to his biographers, Poussin, towards the end of his life, spoke of those early works in which he had imitated Titian's Venetian manner as an aberration. He felt that he had been seduced by the sensuous charms of colour and, turning instead to the Antique and Raphael, he renounced these superficialities in favour of a new emphasis on line and form.

This change, which was to determine the course of his artistic career, can already be detected in *The Bacchanalian Revel* (Plate 3). In the *Adoration of the Golden Calf*, which dates from the second half of the 1630s before Poussin's departure for Paris in 1640, it is fully apparent. Now, in place of the poetic mood and richly atmospheric landscapes of his early works, are groups of fully modelled figures, brightly lit and occupying a clearly defined space. This new style may be less beguiling than the old one, but it is better adapted to re-telling the epic stories of classical mythology and the Bible in an appropriately dignified and heroic manner.

Together with its pendant, *The Crossing of the Red Sea* (Melbourne, National Gallery of Victoria),

The Adoration of the Golden Calf was painted for Amadeo del Pozzo, Marchese di Voghera, who lived in Turin. The subject of *The Adoration of the Golden Calf* is taken from Exodus, chapter 32. Moses, who is shown in the left distance with Joshua, returns from Mount Sinai where he has received the tablets of the Ten Commandments from God, to discover Aaron and the Israelites worshipping the idol of the Golden Calf. In his fury, Moses breaks the tablets and with a body of God-fearing men slaughters the idolaters.

In keeping with his theme Poussin has created a dramatic composition of large scale. The golden calf rises up on a decorated plinth against a sombre cloud-filled sky. Across the foreground the dancing Israelites are frozen in mid-movement, like the carved figures of an Antique bas-relief, and a surge of hands gestures towards Aaron, the instigator of the idolatry, clad in white. But even in the creation of so stern an image Poussin has derived stimulus from his earlier, more seductive work: the three principal dancing figures are repeated, in reverse, from the *Bacchanalian Revel* (Plate 3).

30

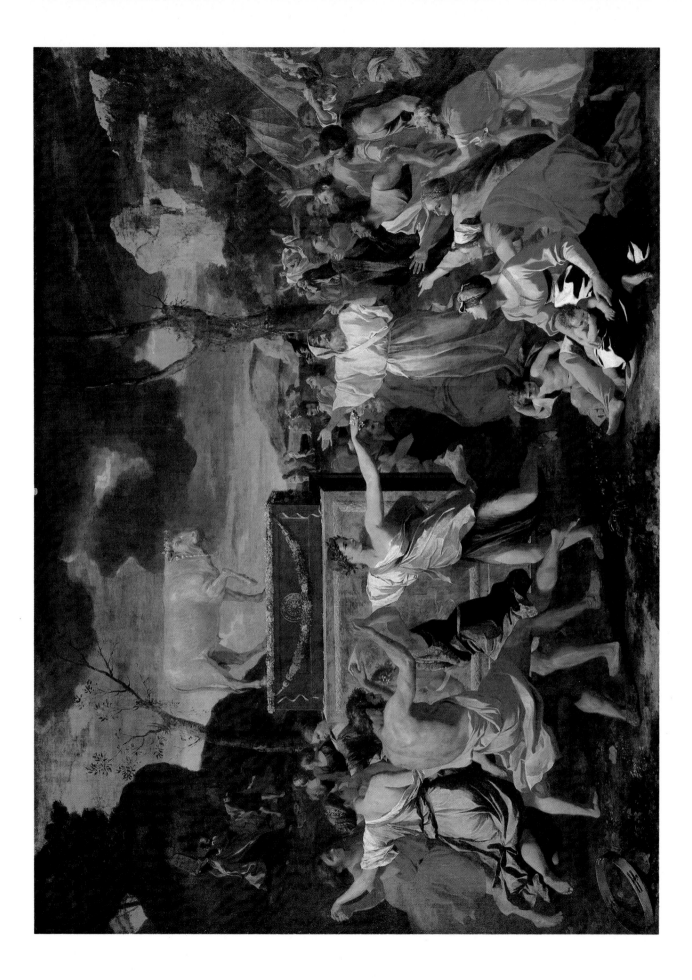

PLATE 6

Nicolas Poussin, 1594(?)–1665

The Adoration of the Shepherds (No. 6277)

Signed: N. Pousin. fe.
Canvas, 98 × 74 cm.
Purchased 1957

The object of worship is no longer the red-faced brazen statue of Pan, or the idol of the Golden Calf, but the Christ Child. While during his early years Poussin was most attracted to themes from classical mythology, Biblical and other Christian subjects become more frequent from the late 1630s, and the next two decades saw the completion of two series of *Sacraments*, Poussin's highly personal celebration of the rites of the Christian Church.

Nevertheless Poussin's Christian world is placed firmly in the classical era. His treatment of the *Sacraments* is in terms of Christ's life and of the history of the early Christian Church. Likewise, this Nativity scene with the Adoration of the Shepherds is rich in classical allusions. Dominating the scene of worship are the ruins of a gigantic Roman edifice, the strong verticals and horizontals of which provide the compositional framework of the picture. The shepherds who bow before the Christ Child are like the Arcadian shepherds that Poussin had painted pondering the inscription on an ancient tomb, while the girl bearing fruit might have stepped from a scene of bacchanalian revelry. And in the middle distance a pair of classically draped figures approach the stable, engaged in discussion like two ancient philosophers.

But Poussin has also paid due regard to the source of his subject, chapter 2 of St Luke's Gospel, and to traditional representations of it. Classical ruins appear in many Renaissance treatments of the theme, and allude to the passing of the Old Dispensation, the Jewish code of the Old Testament. The ox and the ass are likewise traditional features, and Poussin has followed the precedent of earlier *Adorations* in showing in the background the annunciation of the Angel of the Lord to the shepherds, as they watch over their flocks. In rational terms it is illogical to show two consecutive events apparently happening simultaneously, but Poussin is here prepared to accept the example of his predecessors in order to represent faithfully the events of Christ's birth as related by St Luke.

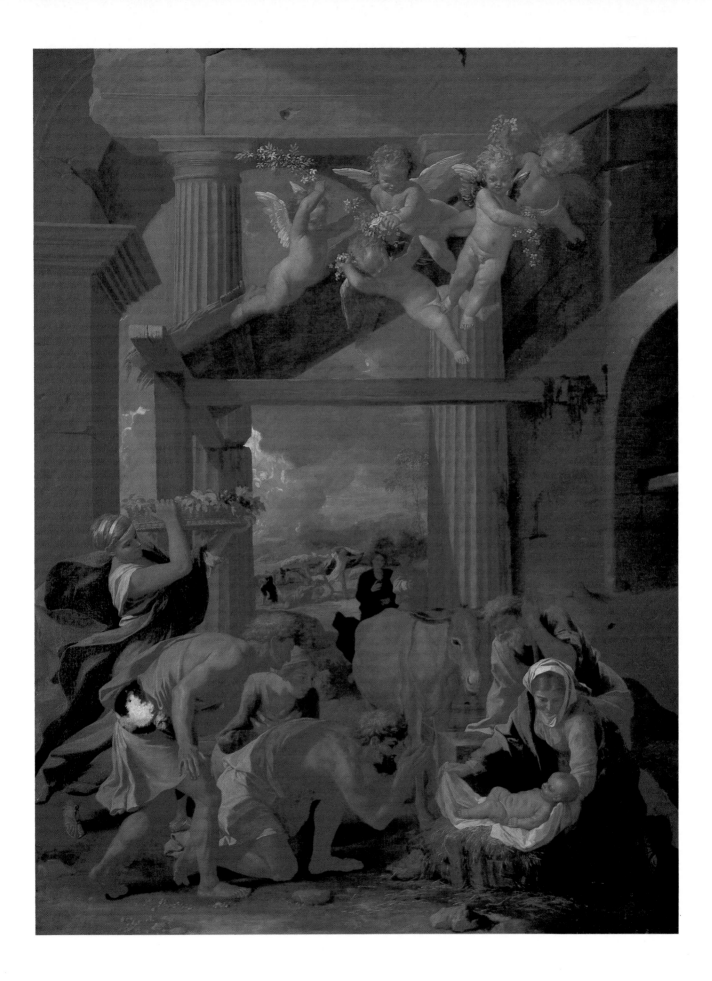

PLATE 7

Nicolas Poussin, 1594(?)–1665

Landscape with a Man killed by a Snake (No. 5763)

Canvas, 119.5 × 198.5 cm.
Purchased 1947

Painted for Pointel, a French friend of the artist, probably in 1648, this picture is contemporary with the pair Claude painted for the duc de Bouillon (Plates 18 and 19), but as a landscape it is very far removed from Claude's airy, light-filled vistas. It is distant, too, from the seductive atmosphere of the *Bacchanalian Revel* (Plate 3). The soft Venetian landscape has been replaced by a grave, natural order, the hazy mountains and shimmering foliage by sharply drawn land and tree masses. This is the very type of the classical landscape, with nature organized according to strict intellectual principles to create an austere harmony of shapes and tones. The view recedes through clearly defined planes to the distant townscape, chiselled by the light into simple cubes and blocks and reflected in the glassy water.

As the picture is dark in tone (perhaps darker than when it was painted, since much of the reddish-brown ground now shows through) so is it sombre in mood. Even a cursory glance conveys a sense of tension and alarm in the figures of the running man and the woman with outstretched arms. To this suspense is added a thrill of horror when the eye discovers the slumped and livid body of a man entwined by a snake.

The sinister subject-matter seems to have no source in classical literature or mythology, although, as with most of Poussin's landscapes, the architecture and dress indicate that a classical context is intended. It has been suggested that the location may be the plain near Fondi which was notorious in the seventeenth century for its infestation by snakes, and the city and general geography do bear some relation to the area. According to Poussin's biographer, Félibien, the subject is the effects of terror. The man in blue discovers the death and conveys his alarm to the woman beyond, who in turn catches the attention of the fishermen on the lake. Like contagion, panic spreads in a zig-zag line from person to person. The note of tragedy cuts into the landscape like the echo of a shriek of terror.

PLATE 8

Nicolas Poussin, 1594(?)–1665

The Annunciation (No. 5472)

Signed: POUSSIN . FACIEBAT . / ANNO SALVTIS . MDCLVII . / ALEX .
SEPT . PONT . MAX REGNANTE . / . ROMA .
Canvas, 105 × 103 cm.
Presented by Christopher Norris, 1944

During his last years, Poussin developed his art along ever more personal lines. The style of his late paintings is strange and eccentric, and bears no relation to the work of his contemporaries in Rome. In contrast to the restless movement and overwhelming illusionistic effects of Baroque painting, everything in Poussin is calm, still and restrained. This unusual painting is no exception. Poussin completely breaks with contemporary practice in his treatment of the theme, and represents the Angel's appearance to Mary in almost ritualistic terms, emphasizing the divine mystery of Christ's conception by the strict avoidance of any show of human emotion.

The origin of Poussin's painting is not known, although it is traditionally said to come from the Pope's chapel, and the inscription, which states that it was painted in Rome in 1657 during the pontificate of Pope Alexander VII, adds some weight to this hypothesis. But it has also been suggested that it was designed to hang in the church of Sta Maria sopra Minerva in Rome, above the tomb of Poussin's friend and patron, Cassiano dal Pozzo, who died in the year the picture was painted.

We know that Poussin was engaged at the end of 1657 in a project for the tomb, which was never finally realized. The unusual square format of the painting and the prominent stone slab which projects to the picture plane where it bears an inscribed wooden plaque (unique in Poussin's work) suggests that it was painted for a particular architectural setting. The pose of the Virgin, seated on the ground like the Madonna of Humility, may link the painting with the church where Poussin's friend was buried, since Sta Maria sopra Minerva was an important centre of the Dominican order, with which the Madonna of Humility had long been closely associated. The theme of the Annunciation also had particular associations with the church, and was, at the same time, appropriate as a memorial to a deceased friend. The Annunciation, at the very beginning of Christ's earthly life, looks forward to its end, to the Passion and his death. The Virgin's pose relates to that of the Pietà, in which she is shown on the ground, bearing the dead body of her son. Furthermore, sitting on the ground is the traditional attitude of mourning.

All of this may help to explain why Poussin breaks so completely with the example of his contemporaries, with the celestial clouds and divine radiance of a baroque Annunciation. In his intense and moving drama, there is only room for essentials. The Angel Gabriel bears no lilies and is accompanied by no soaring cherubim. He kneels before the Virgin, his hands expressing his purpose, while she sits, eyes closed and arms outspread, in a pose of passive receptivity. Strongly lit from the side, these two protagonists are like statues, immobilized in the dim and austerely furnished room. Monumental and grave, they seem to bear witness to Poussin's depth of feeling for his departed friend.

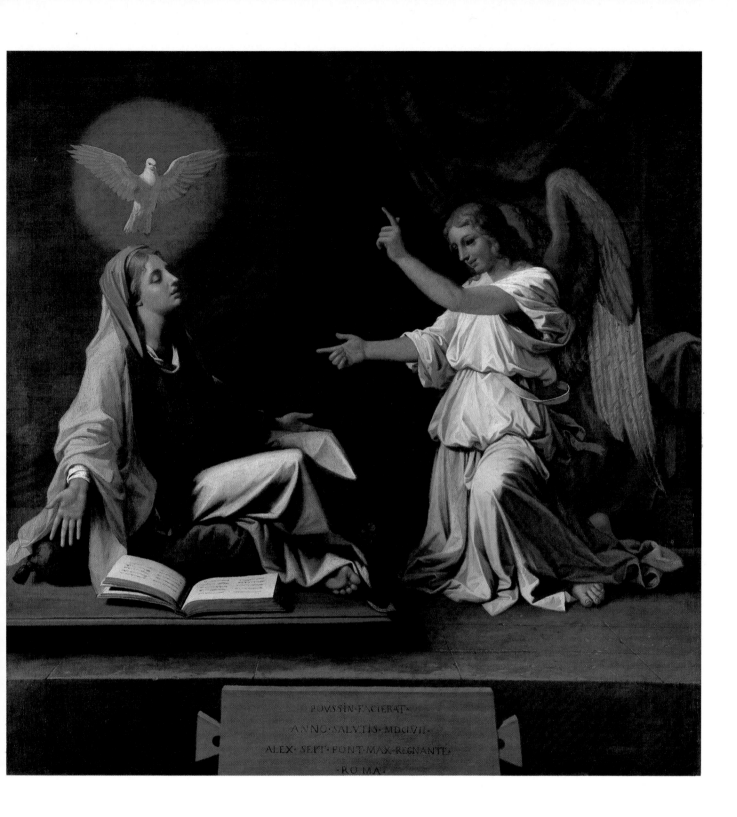

POVSSIN·FACIEBAT·
·ANNO·SALVTIS·MDCLVII·
·ALEX·SEPT·PONT·MAX·REGNANTE·
·ROMÆ·

PLATE 9

Philippe de Champaigne, 1602–1674

Cardinal Richelieu (No. 1449)

Signed: P. DE CHAMPAIGNE .
Canvas, 259.5 × 178 cm.
Presented by Charles Butler, 1895

In 1628, when he returned to Paris from a short visit to his native Brussels, Philippe de Champaigne became official painter to the Queen Mother, Marie de Médicis. In the same year he received commissions from the King, Louis XIII, and in 1634 he painted a large picture for Notre-Dame of the King rendering homage to Christ at the foot of the Cross. At about the same time, to crown his success, he attracted the attention of Cardinal Richelieu, for whom he painted the *Galerie des Hommes Illustres* in the Palais Cardinal as well as decorating another gallery there.

Among the 'great men' in the Palais Cardinal was a portrait of Richelieu himself which is now lost. It was the first of several which Philippe de Champaigne painted of him including this full-length and the triple portrait (Plate 11) which is also in the Gallery. Armand-Jean du Plessis (1585–1642), duc de Richelieu, became a cardinal in 1622 and in the same year was made Chief Minister of France under Louis XIII, a position of enormous power and influence which he retained until his death. He was a notable collector of works of art and commissioned paintings from Poussin (Plate 4) as well as from Champaigne.

Judging from an engraving of the lost portrait of Richelieu painted for the *Galerie des Hommes Illustres*, this full-length is of the same type in terms of pose and costume. Indeed, it has been suggested that it is the portrait painted for the Palais Cardinal in about 1635, but it is in fact too large (larger than the surviving 'great men') and includes a view of a garden leading from an arcade which does not feature in the engraving of the Palais Cardinal portrait. The architectural detail of the arcade seems to correspond to part of the Château de Rueil as represented in contemporary engravings. Richelieu acquired this château in 1633 and this portrait, which dates from about 1637, was probably intended to hang there. It is also likely that this is the picture to which Félibien, writing in the eighteenth century, alludes when he notes that, after the completion of the *Galerie des Hommes Illustres*, Richelieu commissioned Philippe de Champaigne to paint him 'full-length and life-size'.

For the general concept of the pose, with one arm outstretched and the other supporting the folds of the 'capa magna', Champaigne is indebted to the portraits of Van Dyck and Rubens. The treatment of the draperies, however, is more sculptural than that of his two fellow-countrymen and suggests that Champaigne, like Poussin, had been studying Roman statues. In any case the portrait must have pleased, since it was followed by a whole series of imposing full-lengths of the Cardinal by Champaigne, which more or less reproduce the same pose with different backgrounds. A very similar example is in the Royal Collection, at Hampton Court. Others are in the Louvre, at Versailles, in the Chancellerie des Universités in Paris, and in the Polish National Gallery in Warsaw.

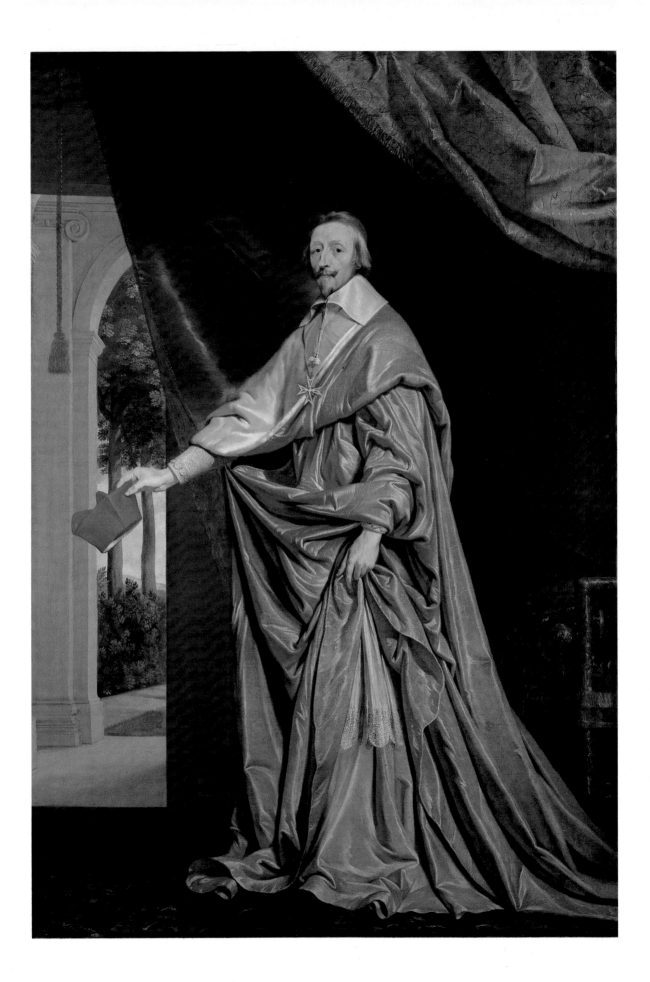

PLATE 10

Philippe de Champaigne, 1602–1674

The Dream of S. Joseph (No. 6276)

Canvas, 211 × 158 cm.

Purchased 1957

This large and impressive painting illustrates a passage from chapter 1 of St Matthew's Gospel which describes how the Angel of the Lord appears to Joseph in a dream to tell him that Mary has conceived of the Holy Ghost, and that she shall give birth to a son, Jesus. The subject was popular with the Catholic Church in the seventeenth century, since it laid emphasis on Mary's purity. In Philippe de Champaigne's picture she is shown in the background, turning from her Bible in recognition of the Angel's presence.

The picture comes from the Chapel of Saint Joseph in the church of the Convent of the Minims, which before its demolition stood near the present Place des Vosges in Paris. It was probably painted in about 1638 and commissioned by M. Mirault, one of the King's ministers, to whom the chapel belonged. Unusual though the composition appears, with the winged figure of the angel descending diagonally towards Joseph, who lies slumped in a posture which counter-balances the angel's movement, it has its source in another picture, an engraving by the Italian Andrea Sacchi of the angel instructing Joseph to flee with Mary and Jesus into Egypt, only that in Sacchi's engraving the angel's position is reversed.

Philippe de Champaigne's debt to Sacchi is only one example of the way he drew upon the work of other artists in forming his own personal style. He was born in Brussels and came first to Paris in 1621 where he finally settled permanently, bringing with him the influence of his countryman, Rubens. The robust figures, with their heavy draperies, the baroque design and dramatic lighting of *The Dream of S. Joseph* all derive from early Rubens, but they are tempered to suit French taste by a liberal infusion of Italian classicism. The smooth, rather anodyne faces of the three protagonists, and the sharp modelling of flesh and draperies in areas of evenly coloured paint owe a great deal to Guido Reni. The turbulent, rhythmic movement which sweeps through Rubens is checked so that the composure of the arrangement is not disturbed.

But Philippe de Champaigne is not without originality. To this blend of Flemish and Italian influences he makes his own idiosyncratic contribution: a concern for detail in the treatment of Joseph's hands and feet, for example, in the representation of a chair or a table, and in the inclusion of many beautifully painted accessories – the chisels and mallets of the carpenter's trade, a needlework basket, a pair of sandals and a roughly woven mat. And in the careful depiction of these, no less than in the figures themselves, Champaigne conveys a feeling of dignity and order which is a measure of the respect he shows towards his subject.

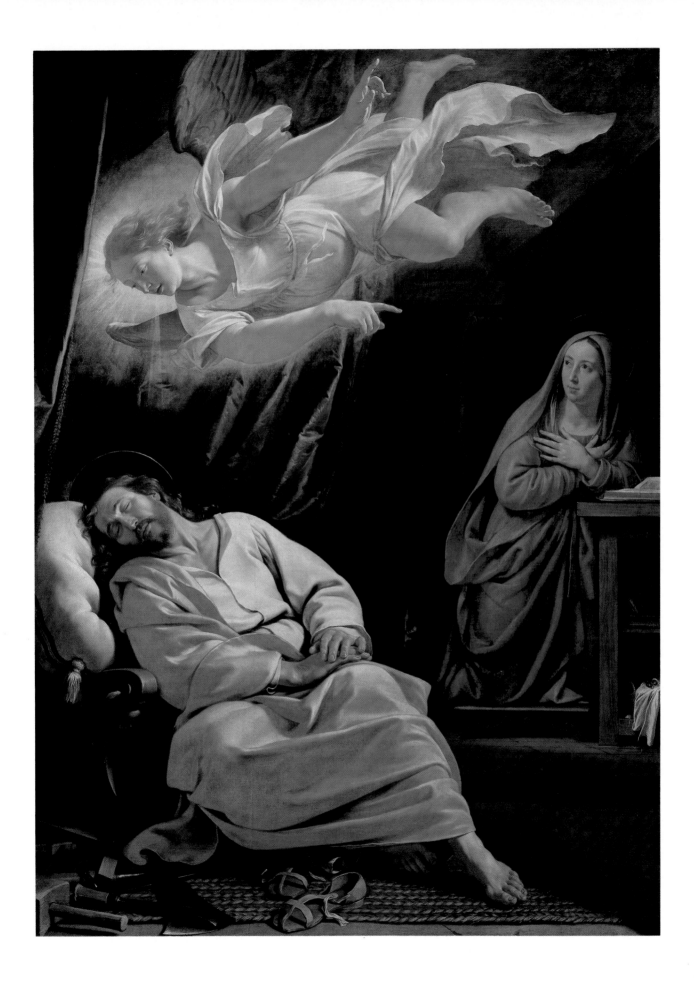

PLATE 11

Philippe de Champaigne, 1602–1674

Triple Portrait of Cardinal Richelieu (No. 798)

Inscribed (above the right head): De ces deux profilz c(elui?) cy
est le meilleur.

Canvas, 58 × 72 cm.

Presented by Sir Augustus Wollaston Franks, 1869

An old inscription on the back of the canvas of this painting states in Italian that it is 'a portrait of Cardinal Richelieu by Monsieur Champaigne [*Monsu Sciampagna*] of Brussels. He made it in Paris to be sent to Rome to the sculptor Mocchi, who then made the statue and sent it to Paris.'

This inscription explains the strange triplication of Richelieu's image on this canvas. The three aspects of the sitter provided the sculptor with a reasonable guide for his own three-dimensional work, necessitated of course by the physical distance separating patron and artist. A note has even been added, above the profile head on the right, presumably by the artist, to the effect that this is the best likeness of the Cardinal. The practice of using painted likenesses for the production of portrait busts was not unusual in the seventeenth century. Since so much depended in such cases on the painter, important patrons made use of the greatest artists, even for what may seem a humble service. Van Dyck provided Bernini with a similar triple portrait of Charles I (in the Royal Collection) to serve him as a guide.

It has been suggested that Champaigne's triple portrait of Richelieu may in fact have been intended for Bernini, who also sculpted a bust of the Cardinal, but we now know that Francesco Mocchi (1580–1654) was working from Champaigne's painting in 1642. The portrait was probably painted in that year or shortly before. The central three-quarter-face likeness presumably corresponds to the type which, according to Félibien, Richelieu approved in 1640, and from which he ordered all his future portraits to be painted and all his past ones retouched.

It certainly resembles closely the head in the earlier full-length portrait (Plate 9). Yet, in the less formal context of the *Triple Portrait*, Philippe de Champaigne seems to achieve a more sensitive portrayal of the Cardinal. He is able to concentrate on his physiognomy, rather than on the trappings of greatness. There are no rhetorical gestures, and for us, as for the sculptor, the three faces combine to give a most penetrating and intimate impression of the man.

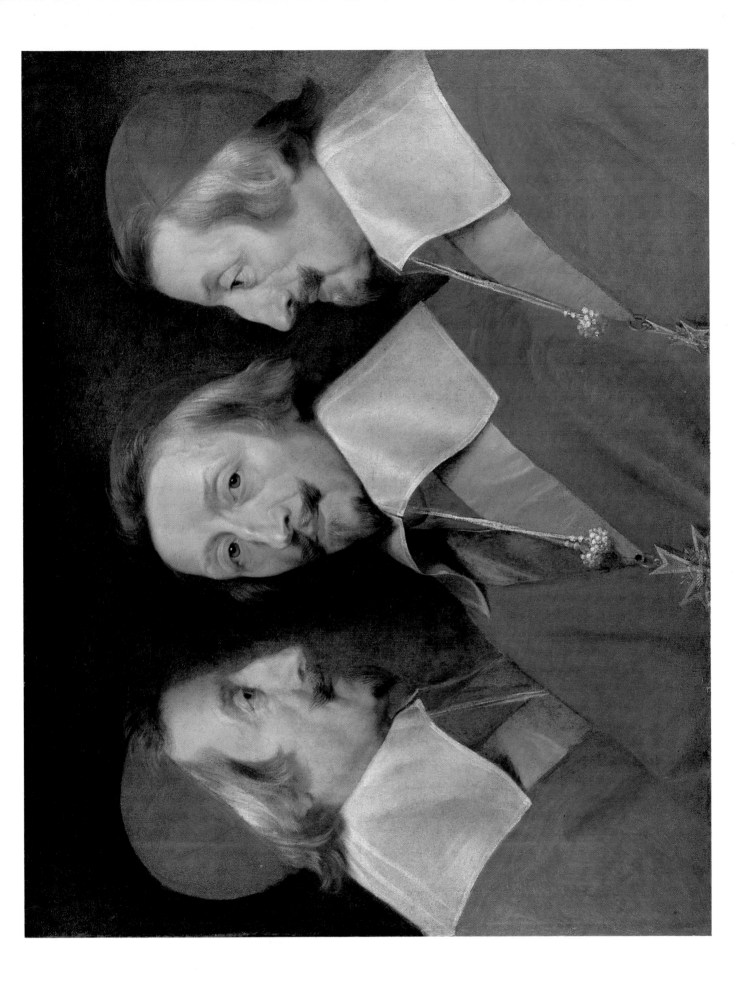

PLATE 12

Antoine(?) Le Nain, *c.* 1595/1610–1648

A Woman with Five Children (No. 1425)

Signed: Lenain. fecit 1642
Copper, 22 × 29.5 cm.
Presented by Lesser Lesser, 1894

Considerable mystery still surrounds the brothers Le Nain, in spite of the increased attention their art has received in recent years. Antoine, Louis and Mathieu were three artist brothers from Laon in eastern France, who came to Paris in about 1629, and in 1648 all became members of the newly founded Académie. Later in the same year two of them, Antoine and Louis, died, while Mathieu survived until 1677. Not a great deal more is known about them.

Of the paintings associated with the brothers, only a handful are signed and these with the family name, 'Le Nain'. The remainder are attributed on stylistic grounds, leaving plenty of room for debate. Nevertheless, as a whole, the work of the Le Nain has a distinct identity, setting it apart from the art of their French contemporaries. Except for a small number of religious and mythological pictures, it documents the life of the period, chiefly as they remembered it from their early years in Laon. Peasant families are shown within humble dwellings or in the open air, with the open plains of eastern France forming an expansive backdrop. In general terms their pictures are indebted to the influence of Flemish and Dutch painting, but in their treatment of their subject-matter they are unique. In the Le Nain's depiction of peasant life there is none of the brutality or coarse humour of genre painting in Flanders or the Netherlands. The humble subjects of their paintings are recorded with the utmost respect.

There is no evidence to show which brother painted which pictures, and it is possible that on some they collaborated. Nevertheless, certain paintings are closely related in terms of composition, handling and scale and seem to be the work of a single hand.

This painting, for example, is one of a number of small, finely executed groups of peasants, mostly on copper, which are usually associated with Antoine Le Nain. Characteristic of them all is the almost naïve treatment, with the stiffly posed figures arranged in a row, facing the spectator, rather as in an early photograph. By avoiding more sophisticated and artistic devices, the artist seeks to create a rigorously truthful likeness of his subject, without rhetoric or sentimentality. He records the simple facts – the inelegant homespun clothes, the rush-seated chair, the earthenware pots – without condescension or contempt, and invests his subjects with a natural dignity.

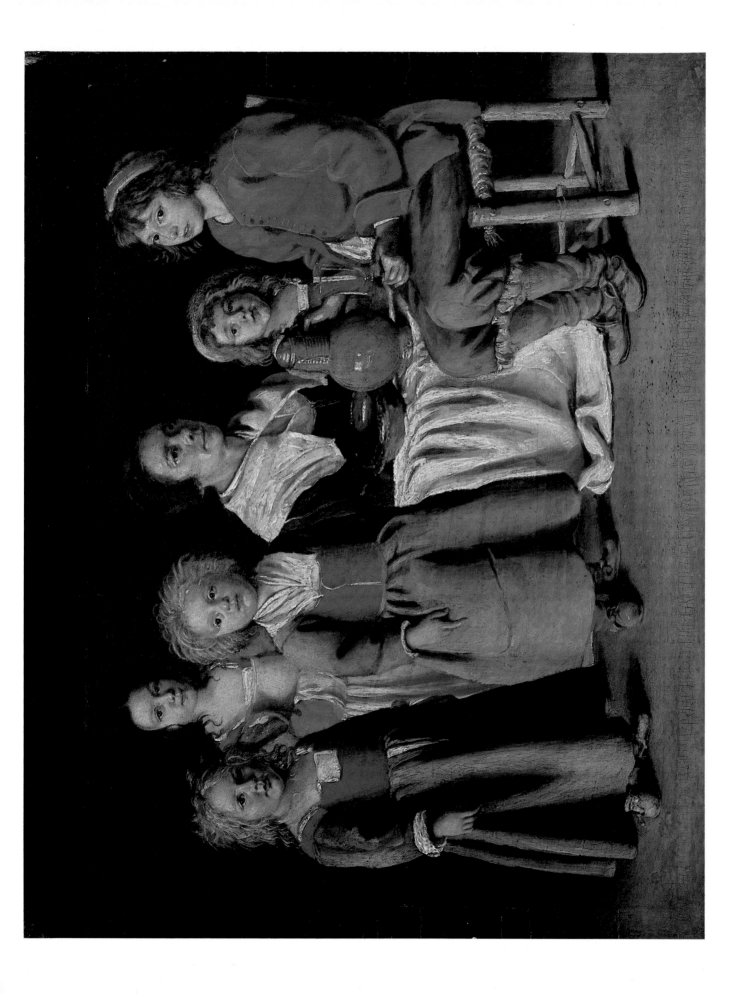

PLATE 13

Louis(?) Le Nain, *c.* 1595/1610–1648

Four Figures at Table (No. 3879)

Canvas, 46 × 55 cm.
Presented by F. Hindley Smith 1924

Until recently this painting was thought to be no more than the best of several old copies of a missing Le Nain. It was only after cleaning, when a number of disfiguring retouchings were removed and the delicate colouring and handling revealed, that it became apparent that this was a Le Nain of great quality – the supposedly 'lost' original itself. The treatment is in every respect consistent with the paintings of peasant families associated with Louis Le Nain – generally considered the finest works that the Le Nain brothers produced. The paint is applied with a light, nervous touch. The faces and hands are sketched in with assurance and sensitivity, capturing the vulnerability of youth and the suffering of age.

The intense sidelight that sharply models forms and casts the background into gloomy shadow is strongly reminiscent of Caravaggio, whose brand of realism seems to have made a lasting impression on the Le Nain. But the Le Nain were content with humble subjects and in this picture the light is used not for dramatic purposes, but to sharpen our awareness of the old woman and her young companions. Isolated against the dark background they acquire a dignity and a composure that raise them above their lowly status.

During cleaning a further discovery was made. X-ray photographs revealed that under the painting was a virtually complete bust-length portrait of a bearded man. The marks visible in the background above the old woman's head are in fact folds in his sleeve. The portrait seems to be a competent work in a rather archaic manner, and can be approximately dated to the 1620s. Although few examples by the Le Nain have survived, their early reputation was largely based on their portraits, and it is probable that this picture is a discarded portrait by one of the brothers.

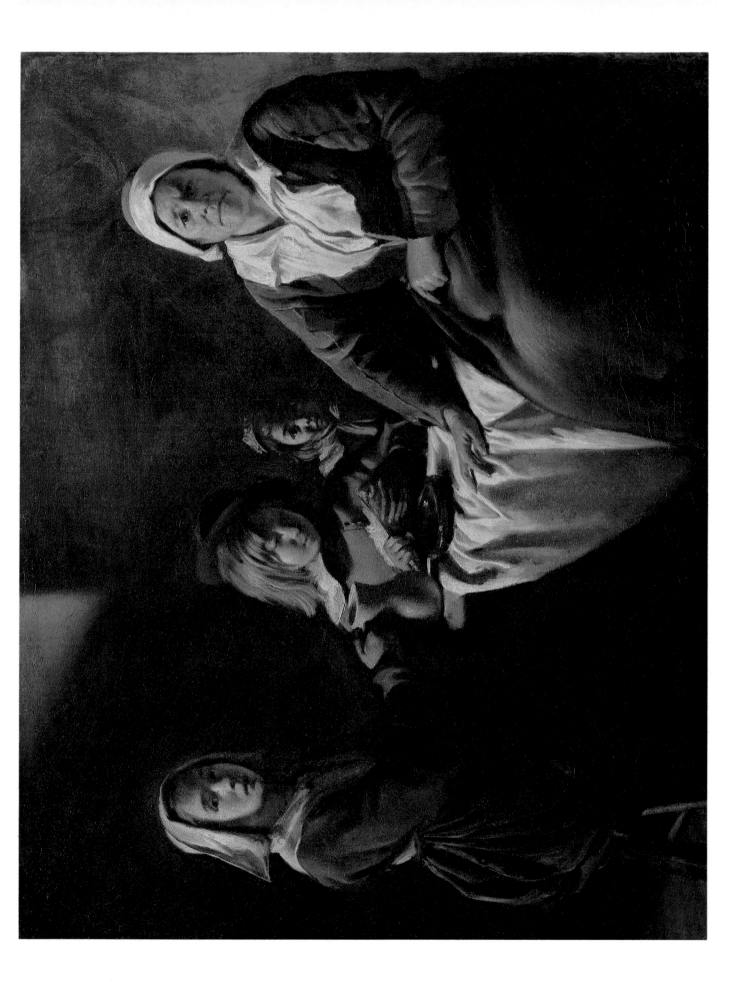

PLATE 14

Louis(?) Le Nain, 1595/1610–1648

The Adoration of the Shepherds (No. 6331)

Canvas, 109.5 × 137.5 cm.
Purchased 1962

The Le Nain brothers are most commonly associated with scenes of peasant families in interiors or in rural landscapes, but they also painted religious subjects. Intended chiefly for churches, these are often larger in scale than their genre paintings. In view of their predilection for peasant scenes, few religious subjects would seem more appropriate to their talents than the Nativity, and in particular the Adoration of the Shepherds, and it appears that many of their religious paintings did indeed treat these themes. Few examples, however, have survived, and notable among them is this Adoration scene, which, before its purchase by the Gallery, was wrongly attributed to Luca Giordano.

Stylistically it belongs, like the *Four Figures at Table* (Plate 13), with the group of works associated with Louis Le Nain. The quiet mood of piety and cool airy tones are particularly characteristic of them. Certain aspects of the composition are conventional features of a Nativity; the classical ruins,

the ox and the ass might be found in an *Adoration* by Veronese or by the Le Nain's contemporary, Nicolas Poussin (see Plate 6). But the broad landscape is that of eastern France where the Le Nain were born, and Joseph and the shepherds come from the same stock as the peasants who appear in Le Nain genre paintings, who doubtless posed for the artist. The roughly cropped heads, the tough unshod feet and weathered arms are observed from life. Even the angels seem, with their tousled hair and curious glance, more like peasant children. Their wings could be cut and glued for a nativity play. And the donkey is harnessed for work, like the beasts of burden that generally appear in Le Nain paintings. Yet none of this is out of character. By depicting the Nativity in terms of the peasant life and rural piety they were accustomed to, the Le Nain succeed in coming all the closer to the spirit of the Gospels.

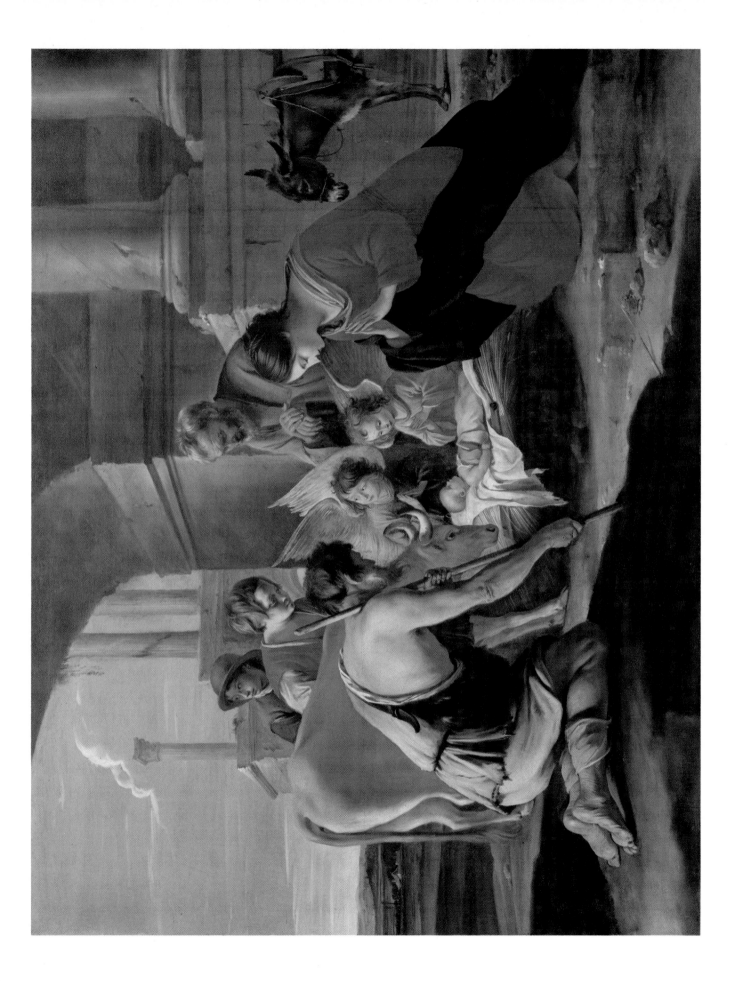

PLATE 15

Laurent de La Hire, 1606–1656

An Allegorical Figure of Grammar (No. 6329)

Signed: L. DE LA HIRE . in ...x.f 1650

Inscribed: VOX LITERATA ET ARTICVLATA / DEBITO MODO (in reverse) PRONVNCIATA.

Canvas, 103 × 113 cm.

Bequeathed by Francis Falconer Madan, 1962

This calm and beautiful painting is one of a series of half-length female figures, representing the seven Liberal Arts: Grammar, Logic, Rhetoric, Geometry, Arithmetic, Astronomy and Music. They were painted between 1648 and 1650 for Gédéon Tallemant, as decorations for a room in his hôtel on the rue d'Angoulmois in the Marais district of Paris. Mariette, writing in the eighteenth century, described them as they appeared *in situ*: 'the figures are not full length; they are life-size, and the pictures are ornamented with architecture and accompanied with children'.

A problem arises, however, from the existence today in public and private collections of ten paintings corresponding to the description, one of which even represents architecture – not one of the Liberal Arts at all. However, there was also said to exist a similar series of paintings by La Hire in Rouen. It seems that he produced two sets, which accounts for the fact that more than one version survives of two of the subjects, Grammar and Geometry. There is a noticeable difference in quality between the two versions of these subjects, and it has even been suggested that the Rouen series was copied from the series commissioned for Tallemant, by Louis de La Hire, younger brother of Laurent. An identical copy of this painting of

Grammar is today in the Walters Art Gallery, Baltimore. However, the fine crisp modelling and delicate paintwork of the London version leave no doubt that it is by Laurent de La Hire himself and belongs to the principal series. The female figure is shown watering plants, an activity symbolic of the vitalizing influence of grammar and correct speech on human behaviour, and she holds a scroll with a Latin inscription which reads, in translation, 'A literate and articulate tongue, spoken in the required manner', a definition of Grammar derived from ancient sources. Like the other allegorical figures in the series, she is shown against a low wall which supports a massive colonnade, while beyond, against a pale sky, are glimpsed the trunks and branches of trees.

In his late years, La Hire was regarded as the leader of what was known as 'Parisian Atticism', in contrast to Vouet's 'Roman Baroque', and in this picture, as in the others of the series, he achieves a particularly restrained and serene classicism. Graceful and still in her sculpted draperies, the smooth-featured young woman is like a Roman statue, posed against the monumental columns behind her. And to this dignified arrangement La Hire brings a note of poetry in the delicate harmony of cool blues, greens, and warm stone colours.

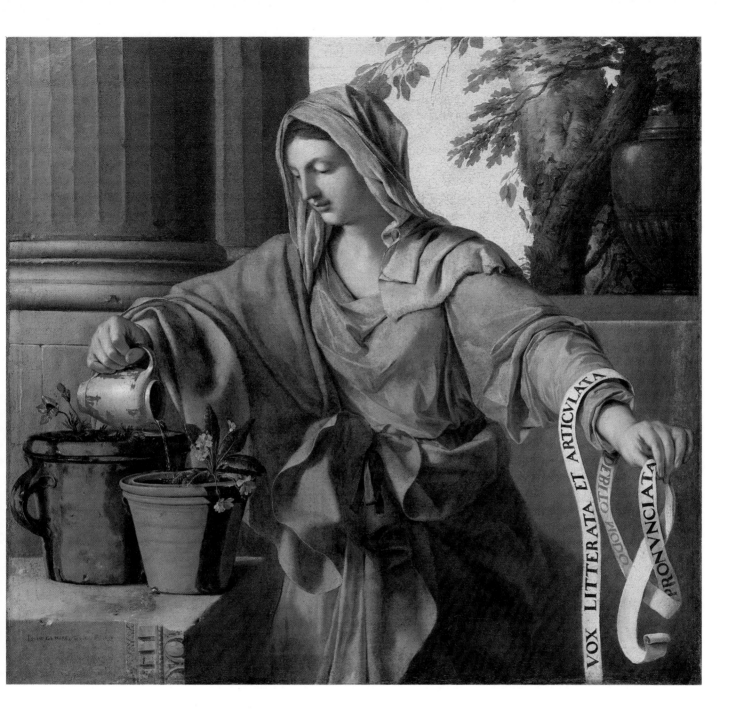

PLATE 16

Claude Gellée, called Le Lorrain, 1600–1682

A Seaport (No. 5)

Signed: CLAVDIO. G.I.V ROMAE 1644 (or 1639)
Canvas, 99 × 129.5 cm.
Purchased 1824

Although Claude was French by birth, he settled in Rome at an early age, apparently to train as a pastry cook, and remained there until his death at the age of 82. It was in Rome that Claude learned the art of painting, and the mood of his landscapes and light-filled coastal views is thoroughly Italian, and richly evocative of the classical past.

This painting is characteristic of the views of seaports for which Claude became renowned in his lifetime. Inspired by visits to Naples and Genoa, they also derive from the colourful harbour scenes of the Fleming Paul Bril, with their ships, sailors and crumbling ruins, but, by virtue of their noble classical architecture and grand central vistas, they are more dignified in character. Claude learned the principles of architectural perspective painting from Agostino Tassi, his earliest master, but while Tassi's buildings are painted with hard tonal contrasts, Claude's are always subordinated to the demands of atmospheric unity.

According to the inscription on the back of no. 43 of the *Liber Veritatis*, the book of drawings which Claude compiled as a record of his paintings, this picture was painted for Cardinal Giorio. The date on the painting is unclear and has been read as 1639 and 1644. Nevertheless, in type this painting belongs with Claude's earlier seaports. It represents no particular historical or mythological scene but, like the works of the Flemish artists with whom Claude associated during his early years in Rome, shows groups of sailors and other figures in contemporary dress. As usual in Claude's works the buildings are imaginary, although they derive from the architecture of modern Rome, particularly the grand palaces of the sixteenth and seventeenth centuries. The large building in the distance, for example, is a variant of the Villa Medici.

But the chief novelty of Claude's work, for which he was so highly esteemed by his contemporaries, is the treatment of light. Rarely had artists dared before to paint the sun. Entirely novel in painting is the truthfulness of Claude's sunset, reflected on the water, touching the scattered clouds, and bathing ships, buildings and men in a warm twilight glow.

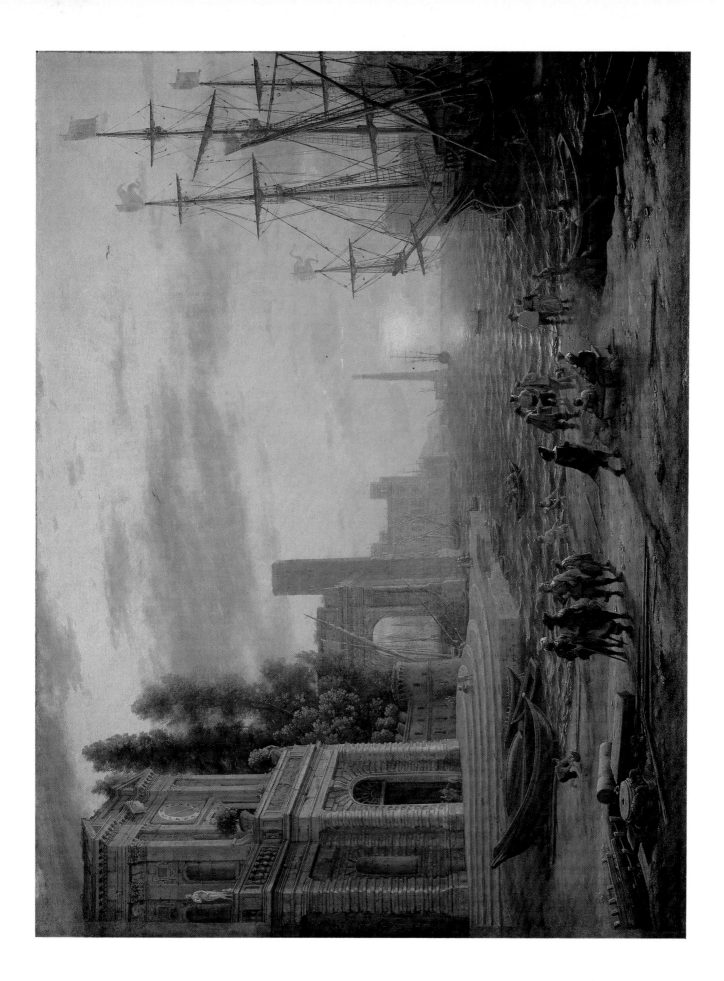

PLATE 17

Claude Gellée, called Le Lorrain, 1600–1682

Landscape with Hagar and the Angel (No. 61)

Signed: CLAVDE / 1646
Canvas, mounted on wood, 52 × 44 cm.
Sir George Beaumont Gift, 1823/8

Such was the fondness of Sir George Beaumont for this little canvas that when he made the gift of his paintings to the National Gallery in 1826 he asked to retain this particular one until his death, not bearing to part with it. 'He dealt with it almost as a man might deal with a child he loved,' said his friend Lord Monteagle. 'He travelled with it, carried it about with him, and valued it beyond any picture he had.' Beaumont's friend, the young painter John Constable, was no less admiring of it. According to his biographer, C. R. Leslie, he 'looked back on the first sight of this exquisite work as an important epoch in his life'.

Claude painted this picture in 1646 for an unknown patron in Paris; it corresponds to drawing no. 106 of the *Liber Veritatis*. In spite of its small dimensions, it seems to embody all that is most characteristic of Claude – transparent, light-filled skies, distant vistas of hills, meadows and rivers, glimpsed, like some view of a promised land, between dark bushes and overhanging trees. The formula, with its dramatic leap into space, is one that Constable himself imitated in such famous paintings as *Dedham Vale* and *The Cornfield*.

However, unlike Constable's landscapes of over a century later, Claude's painting is not pure landscape. Tucked to one side in the foreground of his picture, an angel appears to Hagar and gestures towards the distant hill-town, the home of Abraham. The subject is from Genesis, chapter 16, which tells how the servant girl Hagar conceives a son by Abraham and flees from his house. The Angel of the Lord comes to her, prophesies the birth of her son Ishmael, and instructs her to return to her mistress, Sarah, Abraham's wife. And so, while the elements of Claude's landscape are drawn from the scenery around Rome, the peaceful agrarian scene is evocative of a more distant time, an enchanted world in which such events might be imagined to take place.

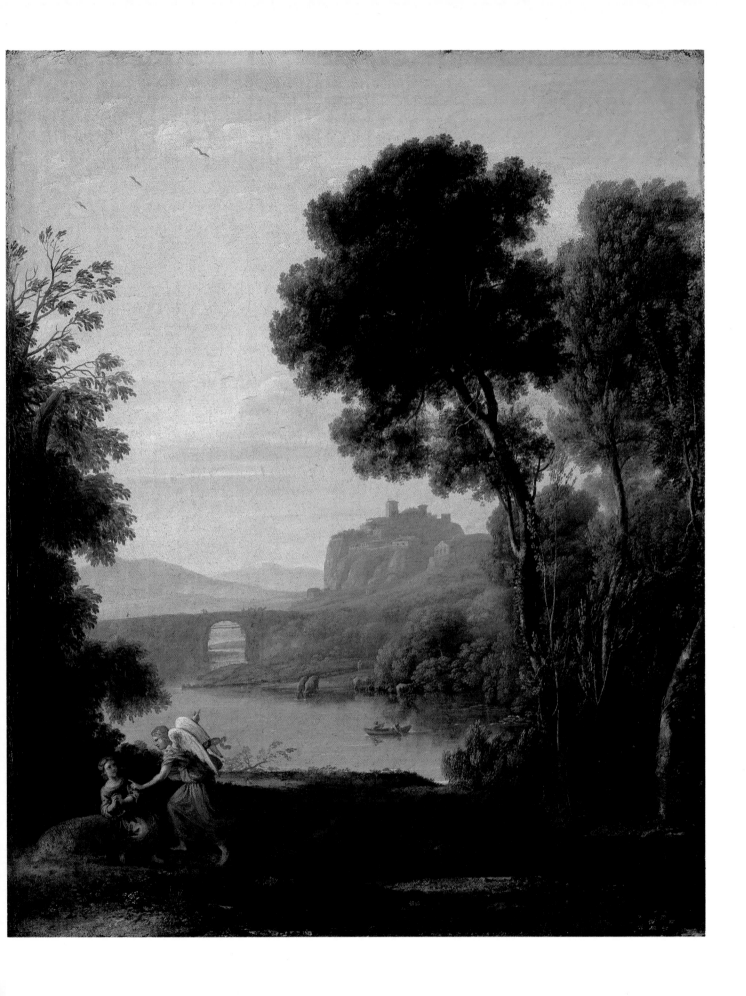

PLATE 18

Claude Gellée, called Le Lorrain, 1600–1682

Landscape with the Marriage of Isaac and Rebekah ('The Mill')

(No. 12)

Inscribed: MARI (age) / DISAC / AVEC / REBECA
Signed: CLAVDIO. G. L. (perhaps over GILLE) / I.N.V. ROMAE 1648 / .F.
Canvas, 149 × 197 cm.
Purchased 1824

This large and impressive landscape and its pendant, the *Seaport with the Embarkation of the Queen of Sheba* (Plate 19), are both dated 1648 and were painted for Frédéric-Maurice de la Tour d'Auvergne (1605–1652), duc de Bouillon, and general of the Papal army in Rome from 1644 to 1647. The pictures have always been together and the *Seaport* bears an inscription with the patron's name (the only instance of this in Claude's work).

All is straightforward until one turns to the corresponding drawings, nos. 113 and 114, in the *Liber Veritatis*. Here *The Marriage of Isaac and Rebekah* is inscribed with the name of Prince Pamphili, a Roman patron, while on the *Seaport* his name is scratched out and replaced by that of the duc de Bouillon. A second version of the *Isaac and Rebekah* exists in the Galleria Doria Pamphili in Rome, and this did originally belong to Prince Pamphili. Instead of a seaport, it has as its pendant a *View of Delphi with a Procession*. The two versions of the *Isaac and Rebekah* composition differ slightly in detail, and in spite of its inscription (with the name of Prince Pamphili) the *Liber Veritatis* drawing corresponds not to the Galleria Doria Pamphili version but to the Bouillon picture. Since the drawing of the *Seaport* also originally bore Pamphili's name, one can assume that the two National Gallery pictures (the 'Bouillon' Claudes) were originally ordered by him. Early in 1647 Pamphili married, renouncing his cardinalate to do so, and in consequence was expelled from Rome by the Pope, his uncle. It seems likely that the commission then fell through but that the duc de Bouillon saw the pair of unfinished pictures in Claude's studio before he, too, left Rome a little later, and requested them for himself. Pamphili must have later renewed his commission, and Claude produced for him a replica of the landscape with a new pendant.

The two 'Bouillon' Claudes, *The Marriage of Isaac and Rebekah* and *The Embarkation of the Queen of Sheba*, bear inscriptions identifying their subjects, both drawn from the Old Testament, but Claude's treatment of the marriage does not correspond to its source in Genesis, chapter 24. Compositionally it derives from earlier paintings by Claude of pastoral dances which have no specific subject. The replica of *Isaac and Rebekah*, painted for Pamphili, bears no inscription identifying the subject, and since it is paired with a picture that is clearly classical in subject, the *View of Delphi*, it cannot, according to Claude's principles of pendants, represent a biblical subject. It is in fact intended as no more than a pastoral dance and became known in the eighteenth century simply as '*The Mill*', a title that has often since been applied to the Bouillon version also.

To the modern viewer, the confusion over patron and subject will matter very little. *The Marriage of Isaac and Rebekah* remains one of Claude's finest and most celebrated landscapes. In juxtaposing this country dance or wedding party against so magnificent a panorama, a landscape in which man peacefully pursues his time-hallowed agrarian tasks, Claude gives an abiding image of harmony between man and nature.

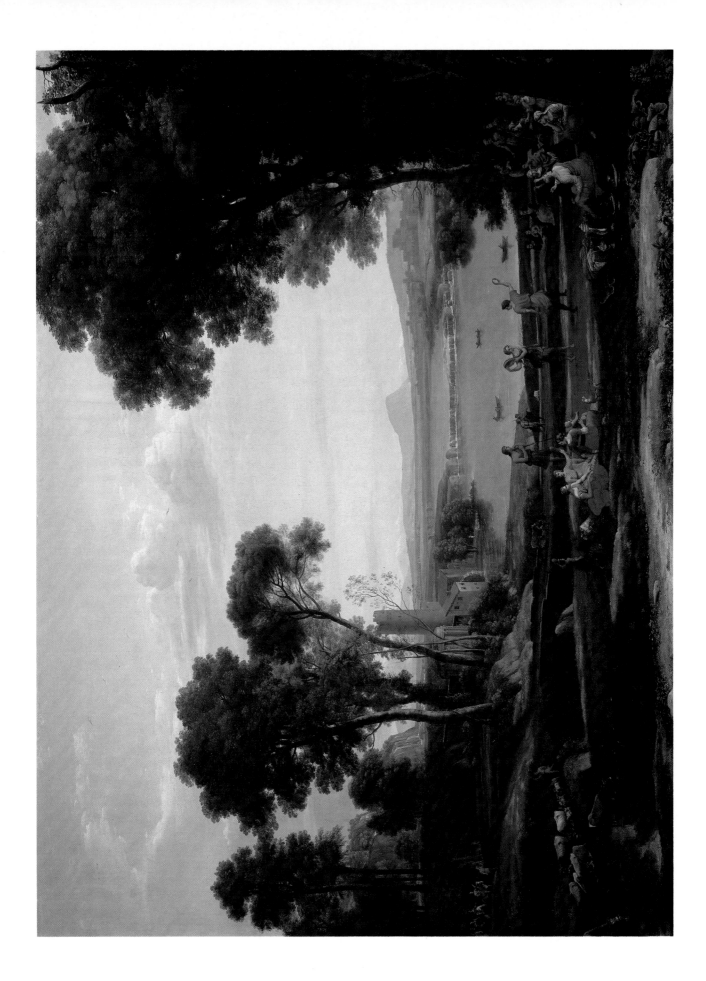

PLATE 19

Claude Gellée, called Le Lorrain, 1600–1682

Seaport with the Embarkation of the Queen of Sheba (No. 14)

Inscribed: LA REINE DE SABA VA / TROVVER SALOMON.
Signed: CLAVDE GILE. I.V. FAICT. POUR. SON. ALTESSE. LE. DVC.
DE. / BVILLON. A ROMA. 1648

Canvas, 148.5 × 194 cm.

Purchased 1824

The story of the Queen of Sheba's visit to King Solomon is told in the first thirteen verses of 1 Kings, chapter 10. 'And when the Queen of Sheba heard of the fame of Solomon concerning the name of the Lord, she came to prove him with hard questions.' She took with her to Jerusalem an abundance of gifts, 'and when the Queen of Sheba had seen all Solomon's wisdom . . . there was no more spirit in her'.

In spite of its brevity, the story has inspired artists of all periods. However, the scene of the Queen of Sheba's departure for Solomon, unlike her reception, is treated only by Claude, in this painting. Although it is not described in the biblical text, it must have appealed to Claude as well suited to the seaport type of composition.

As explained under Plate 18, Claude painted *The Embarkation of the Queen of Sheba* as a pendant to *The Marriage of Isaac and Rebekah* for the duc de Bouillon (as he records in the inscription). The paintings are identical in size and both represent Old Testament subjects of a joyful kind. In other respects they complement each other by contrast: one represents a seaport, the other a landscape; one shows a departure, the setting out of the Queen of Sheba, the other a culmination, a marriage; the embarkation is set at dawn, the marriage celebration in the waning light of afternoon.

Like most of Claude's mature works, *The Embarkation* is constructed with infinite care, and it is to this that it owes its air of dignified calm. All the buildings are placed parallel to the picture plane, and recede in perspective to one vanishing-point, in the middle of the horizon, where Claude has placed the ship that will carry the Queen to Solomon. Buildings and other features of the composition are carefully disposed in accordance with a system of proportions. The picture is divided into fifths both horizontally and vertically: the horizon is at two-fifths of the height, the column on the left and the palace each project one-fifth of the width into the composition, and the tower in the distance stands at two-fifths from the right. The Queen descends the steps from the palace amidst her retinue to the sound of music from the portico above. Small though this procession is, it yet catches our eye, since the Queen is placed immediately below the strong vertical made by the far left column of the palace. She stands at the intersection of the diagonal line of people descending to the quay and the slope of the balustrade bordering the steps. And to give particular emphasis Claude has draped her in red, a colour traditionally associated with power and love.

Claude has the skill to dissemble his art. The mathematical principles on which he bases his composition are disguised by those features which delighted his contemporaries: the naturalness of the treatment of the sea, and the delicacy of the aerial recession into the far distance. Above all, it is the truthfulness of his light effects that brings the painting to life. The rising sun lights up the sea and sky, dissipating the clouds, but has not yet reached the procession on the steps. The Queen and her retinue are seen in the half-light of dawn, the sun just breaking across the columns of the palace and softly illuminating the upper storeys.

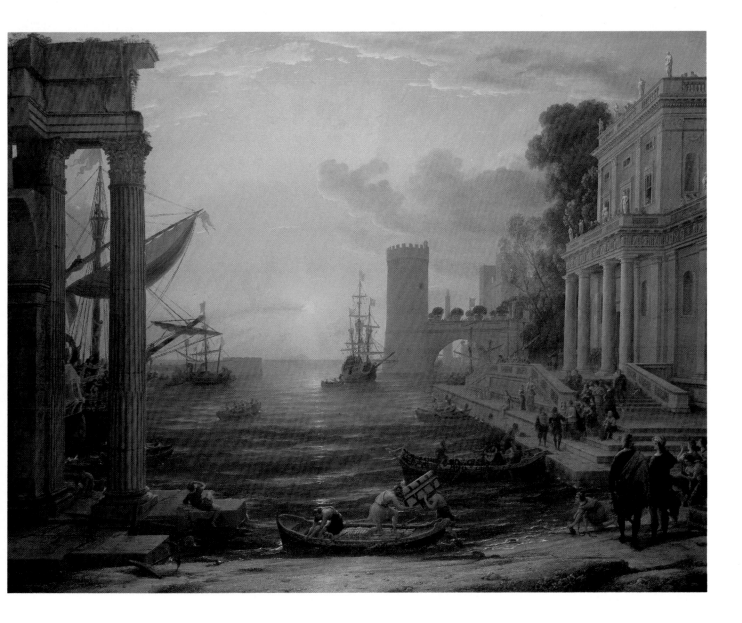

PLATE 20

Claude Gellée, called Le Lorrain, 1600–1682

Landscape with David at the Cave of Adullam (No. 6)

Signed: CLAVDIO Ge(or i)llee. / IVF. ROM(AE) 1658
Canvas, 112 × 185 cm.
Holwell Carr Bequest, 1831

Known as the 'the Chigi Claude', this picture was painted for Prince Agostino Chigi (1634–1705), nephew of Pope Alexander VII, and corresponds to drawing no. 145 of the *Liber Veritatis*. It was intended for the Castel Sant' Angelo in Rome, of which Chigi was made Keeper in 1656, or possibly the palace on the Piazza SS. Apostoli which he occupied in 1657.

The subject, which may have been specified by the Pope, is appropriate for a patron of high office, the captain of the guards. It is taken from II Samuel, chapter 23, which tells how three mighty men break through the ranks of the Philistines to bring David water from the cistern at the gate of Bethlehem. When they return to him on the mountain above the cave of Adullam, he refuses to drink. 'And he said, Be it far from me, O Lord, that I should do this: is not this the blood of the men that went in jeopardy of their lives? therefore he would not drink it.'

The heroic nature of the episode is matched by the grandeur of the landscape. The picture is large and unusually wide in format. In the foreground David and his companions are gathered on a bluff projecting from the craggy mountainside, while beyond stretches a vast panorama extending to sea and mountains in the far distance. On the left, behind the camp of the Philistines, rises the town of Bethlehem with its fantastic assembly of fortifications, towers, temples and pyramids, and just to left of centre stands a single stout tree silhouetted against the bright sky, a symbol of David's stoicism, and by extension a flattering allusion to the elevated position of Claude's patron.

The effect is breathtaking. Few works better match in their richness of landscape description the lavish praise that Turner bestowed on Claude in his Backgrounds lecture of 1811 to the students of the Royal Academy: 'Pure as Italian air, calm, beautiful and serene spring forward the works and with them the name of Claude Lorrain – the golden orient or the amber coloured ether, the midday ethereal vault and fleecy skies, resplendent valleys, campagnas rich with all the cheerful blush of fertilization, trees possessing every hue and tone of summer's evident heat, rich, harmonious, true and clear.'

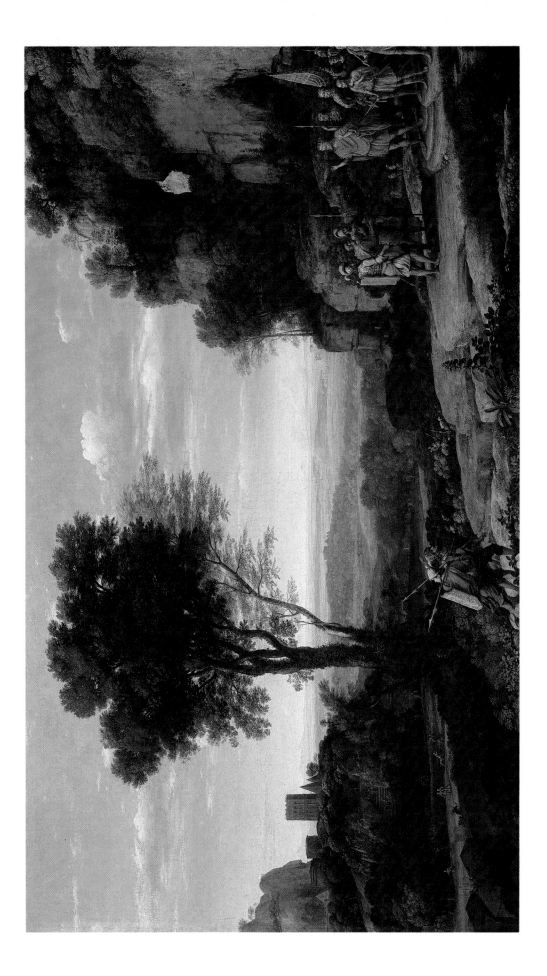

PLATE 21

Claude Gellée, called Le Lorrain, 1600–1682

The Enchanted Castle (Psyche outside the Palace of Cupid) (No. 6471)

Canvas, 87 × 151 cm.
Purchased 1981

> You know the Enchanted Castle it doth stand
> Upon a Rock on the Border of a Lake
> Nested in Trees, which all do seem to shake
> From some old Magic like Urganda's sword.

Thus begins the richly allusive account of Claude's painting that Keats wrote in a verse letter of 25 March 1818 to his friend John Hamilton Reynolds. Keats was a great admirer of Claude's paintings, many of which, including *The Enchanted Castle*, had found their way into England during the eighteenth century. But in writing his fanciful description he was probably remembering William Woollett's famous engraving of the painting of 1782, in which it is first entitled *The Enchanted Castle*. Keats mistakes the solitary figure seated in the foreground for a herdsman and, like most of his contemporaries, seems to have had no knowledge of the painting's true subject.

This we know from the historian Filippo Baldinucci, who, in his account of Claude's life written shortly after the artist's death, describes it as 'Psyche on the seashore', a picture 'of outstanding beauty'. Executed in 1664, it was the second of at least nine paintings that Claude painted for Prince Lorenzo Onofrio Colonna (1637–1689), Duke of Palliano and Tagliacozzo, and Grand Constable of the Kingdom of Naples, and corresponds to no. 162 of the *Liber Veritatis*. The subject is taken from the classical story of Cupid and Psyche as recounted by the Roman writer Apuleius in his *Metamorphoses* or '*Golden Ass*'. The god Cupid falls in love with Psyche and takes her to his magical palace. He conceals his identity and, forbidding Psyche to look on him, visits her only at night. Psyche disobeys his command and while he is sleeping takes a lamp to discover who he is. He awakes and abandons her, and only after she has undergone many trials is Psyche reunited with him. In 1665 Claude painted a second episode of the story for Colonna as a pendant to *The Enchanted Castle*, *Liber Veritatis* no. 167 (now in the Wallraf-Richartz-Museum, Cologne), which shows Psyche saved from drowning herself.

The mood of *The Enchanted Castle* leaves no doubt as to what part of the Psyche story it illustrates. The cool, grey-green colouring of the twilit landscape is expressive of a deep melancholy, which is echoed in the bowed figure of Psyche, deserted by her lover and so conspicuously isolated in the wide expanse of wild nature. Her pose is derived from the treatment of Psyche in an influential series of sixteenth-century engravings of the story by the Master of the Die, after paintings by Michiel Coxie (a source which helps to explain the uncharacteristically heavy proportions of Claude's figure). In the centre of the broad composition silhouetted against the dawn sky, the dark mass of the castle rises up forbidding and awesome, reinforcing the mood of desolation and itself desolate, an open casement in the façade bearing witness to Cupid's flight. This detail in particular must have lodged in Keats's mind, since in 1819 when he was composing the 'Ode to a Nightingale' he once again drew inspiration from Claude's picture for the memorable image of 'magic casements, opening on the foam/ Of perilous seas in faery lands forlorn'.

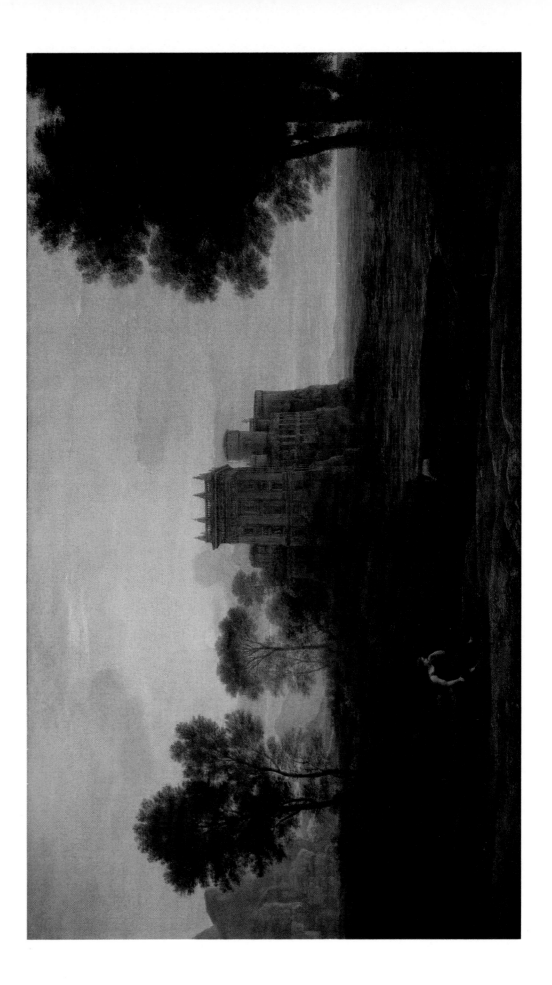

PLATE 22

Claude Gellée, called Le Lorrain, 1600–1682

Landscape with Aeneas at Delos (No. 1018)

Inscribed: ANIVS ROY. SACER(D)OTE (DI) APOLLO., ANCHISE, ENEA.
Signed: .CLAVDE. GILLE. INV. FE. ROMAE. / 1672
Canvas, 100 × 134 cm.
Wynn Ellis Bequest, 1876

This painting is the latest in date by Claude in the Collection, and was painted when the artist was over seventy. According to an inscription on the corresponding drawing in the *Liber Veritatis*, no. 179, it was commissioned by a Frenchman, a Monsieur Dupassy, about whom nothing is known.

It is one of seven paintings based on the story of Aeneas, all but one of which date from the last decade of Claude's life. His sources for this particular episode are book III of Virgil's *Aeneid* and book XIII of Ovid's *Metamorphoses*. Aeneas and his companions arrive on the island of Delos, and are shown the holy sites by Anius, King of Delos and priest of Apollo. Anius, dressed in long white robes and wearing a laurel wreath, gestures towards two trees, an olive and a palm, to which the goddess Latona clung when giving birth to Diana and Apollo. A bas-relief at the top of the portico in the right foreground represents Apollo and Diana killing the giant Tityus who tried to ravish their mother. Beside Anius are Aeneas, in red, with his father Anchises and his son Ascanius, and behind them is the circular temple of Apollo, which Claude has based on the Pantheon in Rome.

Claude's late style corresponds to the heroic vein of the *Aeneid* and the nobility of its verse. There is a greater clarity of composition, the lighting is calm and even, and the colour restrained. Virtually the entire painting is built up of subtly modulated blues and greens. A greater refinement shows in the elegance of the architecture and the delicacy of the trees and figures, seemingly allowing more air to circulate through the picture. Claude evokes the Golden Age above all in his curiously elongated figures. The distortion of scale, fiercely condemned by Ruskin, distances the action and mirrors the sophistication of Virgil's verse.

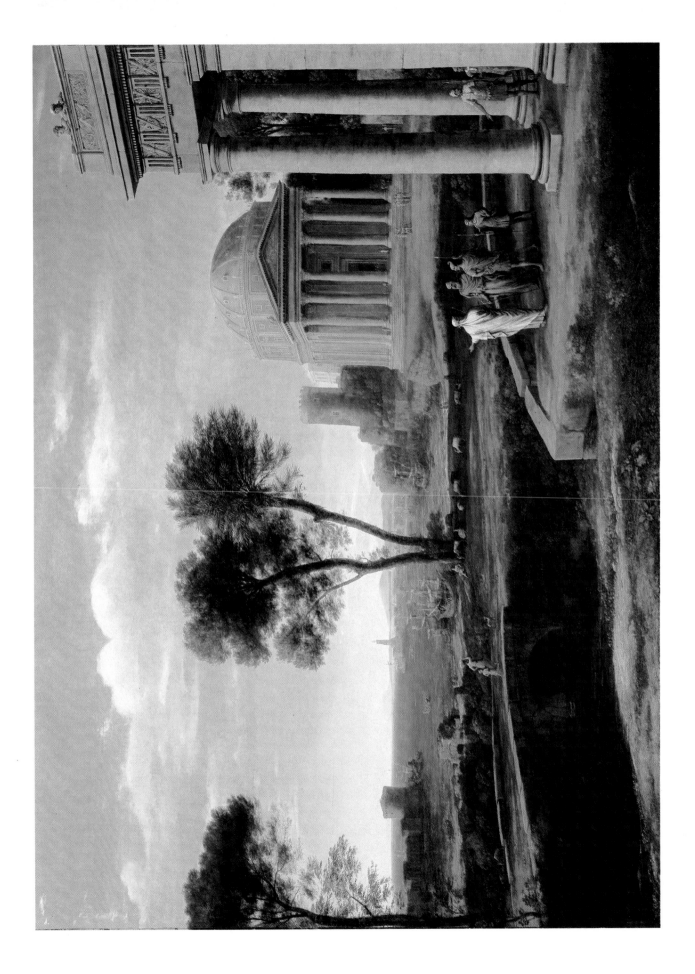

PLATE 23

Sébastien Bourdon, 1616–1671

The Return of the Ark (No. 64)

Canvas, 108 × 134 cm.
Sir George Beaumont Gift, 1823/8

No French painter of his century was more eclectic than Sébastien Bourdon. He was capable of imitating almost any style but never evolved a distinct one of his own. As a young man he spent three years in Rome, where he imitated the peasant subjects of the Dutch and Flemish artists settled there, as well as Giovanni Benedetto Castiglione's scenes of shepherds and herdsmen with their flocks. From 1652 to 1654 he worked at the court of Queen Christina of Sweden where he chiefly painted portraits. At Montpellier, his birthplace, he painted in about 1659 a vast altarpiece for the cathedral, and in his last years in Paris he produced landscapes and religious works cast in a Poussinesque mould.

The Return of the Ark is a characteristic example of Bourdon's imitations of Poussin's classical landscape style. So exaggerated, in fact, is his treatment of the formulas of classical landscape that the painting has a contrived and artificial air. Certain areas, such as the cascade on the left, or the distant city view on the right, are scarcely legible in naturalistic terms and become flat, abstract patterns. The composition is arranged in horizontal tiers, parallel to the picture plane, against which Bourdon sets off the verticals of buildings and trees to create a rigid rectilinear structure. Yet he gives no sense of recession. The landscape piles up upon itself, each plane a shallow silhouette of cut-out shapes, rising up to a sky that is as flat as the cardboard rocks and mountains. The lighting is as unnatural as the landscape, falling with no consistency and serving only to accentuate the silhouette of rocks, trees and clouds.

The subject is from the first book of Samuel, chapter 6, which describes how the plague-stricken Philistines return the Ark of the Lord to the Beth-shemites. Drawn by two oxen, the Ark has miraculously stopped at the great stone of Abel and is hailed by a group of Beth-shemites. According to an inscription on the back of the original canvas, the picture appears to date from 1659 and to have been intended for a Mr Thomas, presumably an Englishman. It is known to have been in England by 1775, and to have subsequently belonged to Sir Joshua Reynolds, who in his *Fourteenth Discourse* to the students of the Royal Academy described it as an example of 'the poetical style of landscape'. A worn inscription on the stone at the bottom right of the painting and repeated on the back of the old lining canvas reads: 'This Picture was bequeathed to Sir George Beaumont Bart. by His Illustrious friend Sir Joshua Reynolds in the year 1792.' It was Sir George Beaumont, devoted admirer of Claude and patron of Constable, who presented it to the National Gallery as part of his Gift to the Nation.

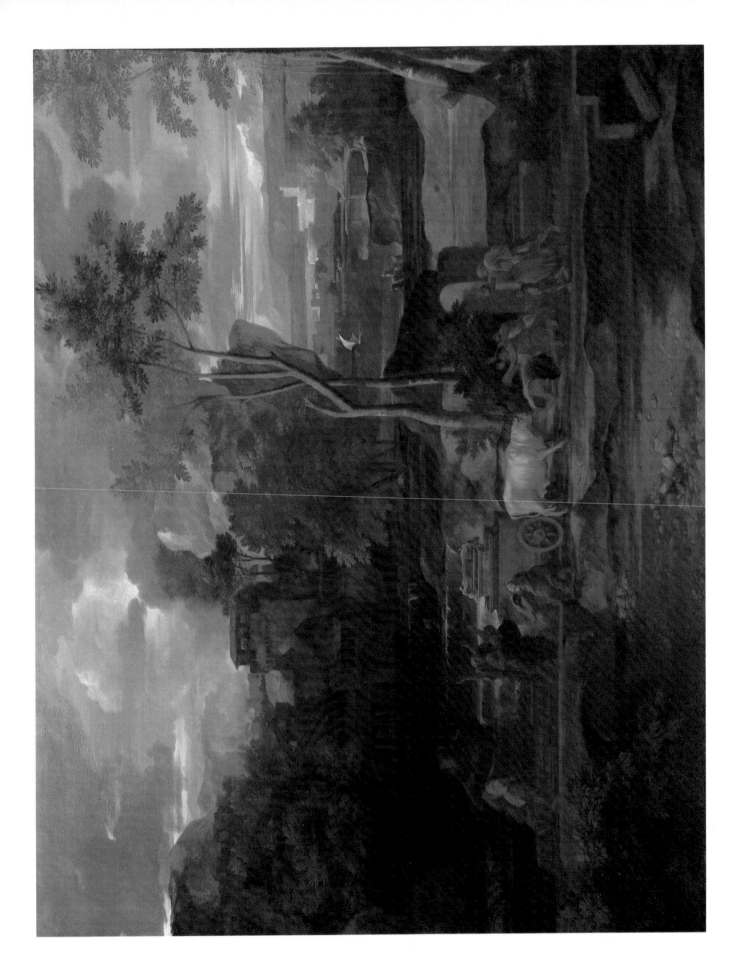

PLATE 24

Gaspard Dughet, 1615–1675

Storm : Elijah and the Angel (No. 1159)

Canvas, 201 × 153 cm.
Purchased 1884

Although he forms part of the French classical landscape tradition, Gaspard Dughet was born and died in Rome, and his mother was Italian. But he trained under Nicolas Poussin, who married his sister, and he even adopted his brother-in-law's name, thus giving rise in subsequent centuries to the confusion of the two artists' work and personalities.

Yet, unlike his more famous relation, Gaspard Dughet devoted all his energies to landscape painting. Encouraged by Poussin, he studied extensively in the Roman Campagna, drawing from nature, and gained a reputation, with Claude and Salvator Rosa, as one of the three leading landscapists of his century. While his work conforms to the general rules of classical landscape, with a carefully established recession and framing trees, Dughet incorporates an extraordinary degree of naturalistic observation which won him the admiration of his contemporaries. Above all, they esteemed his storm scenes. In the nineteenth century Waagen wrote that he 'appears to greatest advantage when he shows the elements in the most violent convulsion – when the tempest sweeps over the land – when the lightnings flash through the dark clouds.'

This painting, which dates from the late 1650s or early 1660s, Waagen considered 'a *chef-d'œuvre* of this great master – nay . . . it is a *chef-d'œuvre* of landscape painting'. It entered England at the end of the eighteenth century, and contributed to the popular enthusiasm for sublime and dramatic scenes, and left its mark on English landscape painting. The subject is derived from the Old Testament (1 Kings, chapter 19), and shows the Angel appearing to Elijah on Mount Horeb, exhorting him to 'go forth, and stand upon the mount before the Lord. And behold the Lord passed by, and a great and strong wind rent the mountains and broke in pieces the rocks before the Lord.'

But of course the figures are merely incidental. They are probably not the work of Dughet at all, but of a collaborator. The real subject is the windswept landscape, dark below the threatening sky, and illumined by fitful gleams of light. What Dughet's contemporaries so relished and what today is still so impressive is his dramatic vision of nature, his panorama of mountain, forest, cataract and flood caught up in the turmoil of a violent storm.

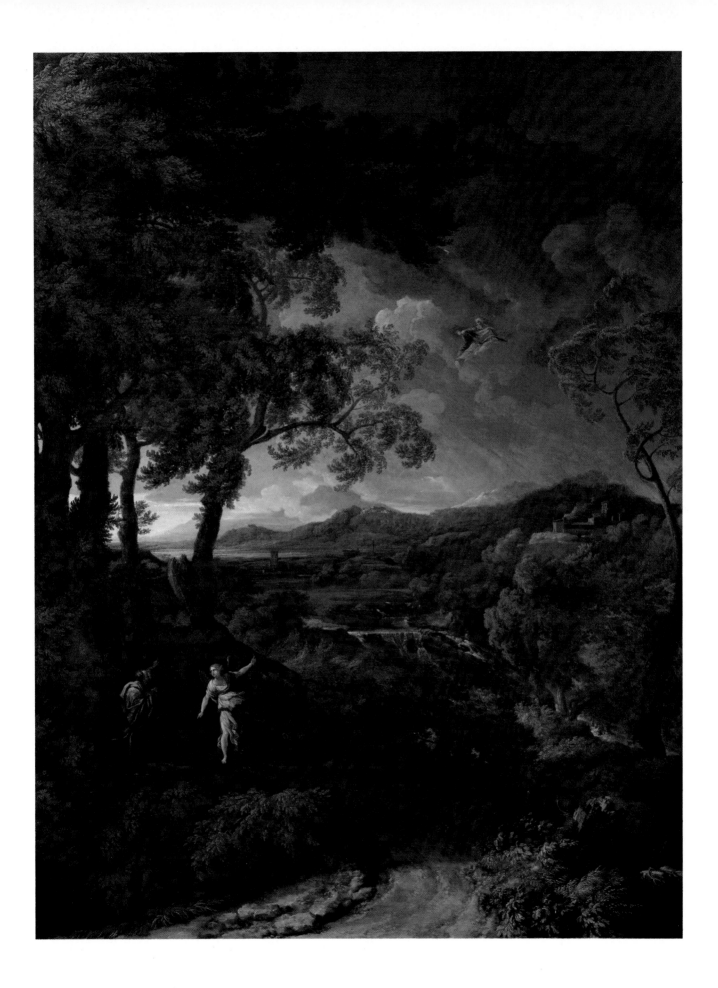

PLATE 25

Gaspard Dughet, 1615–1675

Tivoli (No. 161)

Canvas, 71.5 × 166.5 cm.
Bequeathed by Charles Long, Lord Farnborough, 1838

In his late works, Gaspard Dughet demonstrated his complete mastery of landscape painting in the way he was freely able to deviate from the strict principles governing classical landscape composition, and invent new forms and new decorative effects. The results are original, and enchanting.

Nowhere better can this spirit of invention be seen than in this magnificent painting of about 1670. The curiously elongated format no doubt refers to its intended location; it may perhaps have been painted as an overdoor. It was imported to England from the Palazzo Colonna some time before 1811, and was presumably commissioned to hang in that palace, although it is not known where. Dughet has exploited this format, which would have defeated a lesser artist, to wonderful effect. The composition unfolds across the canvas in a series of interwoven scenes, linked by the undulating forms of the landscape, the serpentine paths, and the rippling bands of light and shade. Quite unclassical is this unregimented diffusion – the lack of a single point of focus, and the multiplication of diverting incidents. As in nature the eye travels across the panorama, attracted now to a distant snow-capped peak, now to a ravine and waterfall, now to a farm half obscured by trees, now to the several small figures that animate the landscape at intervals.

Yet this casual, seemingly unpremeditated view is held together in a single unity as skilfully as the strictest essay in classical composition. The figure groups are linked in their arrangement one to the next and bind the composition rhythmically, while at the heart of these undulating slopes and intersecting diagonals is the distant hill town, a cluster of broadly painted forms perched above a mountain torrent, based perhaps on the ancient city of Tivoli near Rome.

No less remarkable in this late example of Dughet's work is the handling. As the composition is loosely structured, so is the paint applied freely and effortlessly, brilliantly evoking the rich diversity of natural forms without recourse to detailed naturalistic description. The fluent brevity with which Dughet captures the foam of a cascade, the plume of smoke rising from a distant building and the play of light on foliage, rock and water conveys a sense of freshness and immediacy which confirms the truthfulness of his observation.

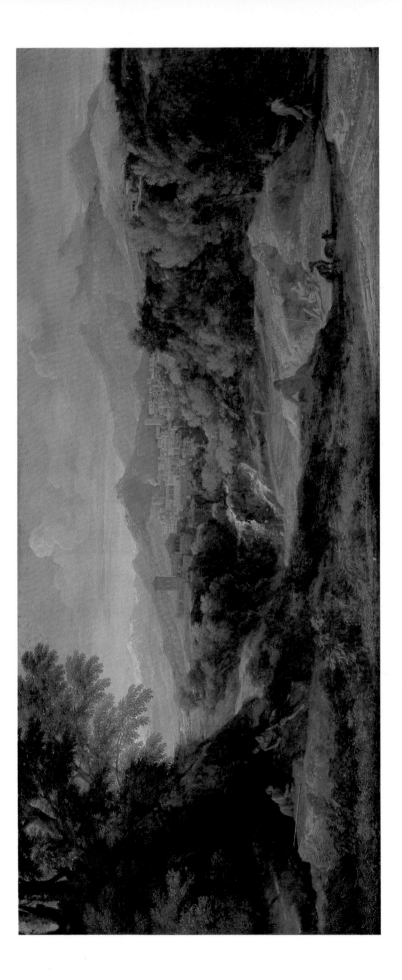

PLATE 26

Francisque Millet, 1642–1679

Mountain Landscape with Lightning (No. 5593)

Canvas, 97 × 127 cm.
Purchased 1945

Little is known about the painter of this beautiful and dramatic landscape. He was born in Antwerp, Jean-François Millet, of French parents and in 1659 moved to Paris where he established himself as a painter. But very few of his works are documented, and while many paintings are today attributed to him there is little evidence to substantiate such attributions. Since he died young it is very likely that many of the paintings given to him are in fact the work of other, obscure landscape painters.

It seems that the greater part of Millet's work comprised classical landscapes, in the manner of Nicolas Poussin. A number of his paintings were engraved at an early date by a certain 'Théodore' (possibly a pupil of Millet) and fall into this category. This landscape is one of them. Various attempts have been made to identify a subject; *The Destruction of Sodom and Gomorrah* and The *Flight of Ahab* have been suggested, but do not seem to fit. Nevertheless, the oddly assorted foreground figures, which include what seems to be a pair of lovers, a horseman and a draped woman with various gesticulating youths, certainly suggest that some story is intended. They are classically garbed, and on a rocky projection behind them is a classical archway.

The landscape, however, does not appear to be invented. The detailed description of the overall geography with its mountains, lowlands, lake and river, and of the individual parts of the landscape with its villages, fields and woods, and the absence of the customary compositional devices of classical landscape all point to this being a depiction of a real scene – presumably in the Alps. The absence of framing elements results in an arresting sense of immediacy and contemporaneity. The river flows in at the bottom left corner of the picture and the lake continues out of sight on the right, giving a sense that this really is just a glimpse of an extensive panorama, caught for us by the artist. The treatment of the storm and lightning is – in comparison, for example, with Dughet's (Plate 25) – unconventional and realistic, as is also the way the artist has conveyed the effect of the land falling steeply away from the foreground eminence. It is as though the artist has brought to the mountainous Italianate landscape favoured by Poussin a naturalistic approach derived from Flemish or even Dutch painting. And to add to this impression that we are witnessing a real scene in the seventeenth century, and not an episode from classical or biblical history, there appears to be among the cluster of buildings in the centre of the picture a medieval church with a spire.

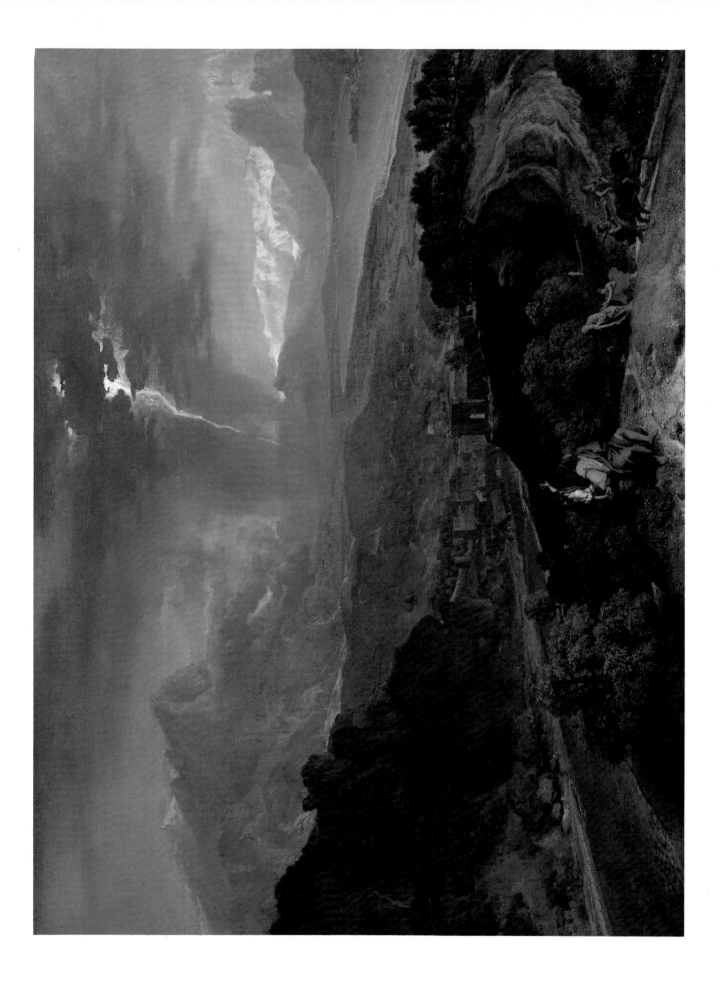

PLATE 27

Pierre Mignard, 1612–1695

The Marquise de Seignelay and Two of her Children (No. 2967)

Signed: P. MIGNard / PINxIT. 1691.
Canvas, 194.5 × 155 cm.
Bequeathed by Sir John Murray Scott, 1914

What might well strike the modern observer as absurd in this portrait was regarded at the time of its production as the height of elegance and dignity. To be shown in the guise of the gods and heroes of mythology conferred upon the sitter a touch of glamour much to be envied. At the same time, the allusion to classical mythology elevated the status of the portrait, raising it closer to the rank of history painting, the most highly esteemed category of painting. During the eighteenth century this hierarchy of categories was to be much eroded, as the taste for a less aristocratic art and greater simplicity encouraged the development of much more naturalistic portraiture.

Here the marquise de Seignelay is depicted as the sea-nymph Thetis, grand-daughter of Poseidon. Her sons are shown as the hero Achilles, son of Thetis, and Cupid, god of love. As the abbé de Monville, in his life of Mignard, observed, the marine imagery is an allusion to the marquise's late husband, Jean-Baptiste Colbert de Seignelay, who, until his death in 1690 after the naval battle at Dieppe, was Secretary of the French Navy. The marquise de Seignelay was born in 1662, Catherine-Thérèse de Matignon, marquise de Lonray. She married in 1679 and had five sons, the eldest of whom, Marie-Jean-Baptiste (1683–1712), and the youngest, Théodore-Alexandre (1690–1695), are included in the portrait. In 1696 she was married again, to Charles de Lorraine-Armagnac, comte de Marsan, and in 1699 she died.

Mignard's portrait gives us little idea of the character of either the marquise or her sons. Their faces are expressionless and their personalities are overwhelmed by the elaborate charade. The marquise, as Thetis, wears her hair adorned with pearls and coral, and stiffly holds up a locket on a string of pearls, perhaps some kind of memento of her dead husband. Her elder son stands garbed in classical armour, a helmet and shield at his feet, the boy Cupid presents a shell goblet filled, again, with coral and pearls, and the narrow foreground is littered with exquisitely painted shells. Although, in his rivalry with Le Brun, Mignard was more progressive in his preference for Rubensian effects and rich colour, when he succeeded Le Brun as *premier peintre du roi* and Director of the Académie in 1790 he turned away from naturalism back towards a more classical style. In spite of the intense colouring, Mignard has here arranged his sitters in a row, like a sculpted frieze. Their flesh, like their draperies, has the hardness of stone, while the sombre landscape behind them is as flat as a painted backdrop.

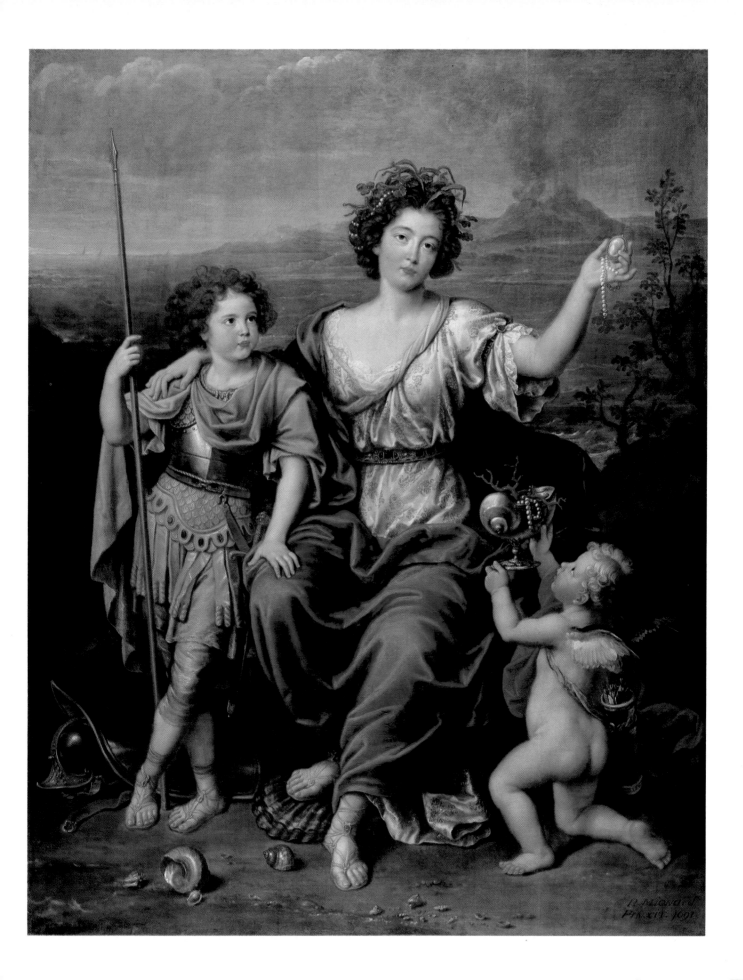

PLATE 28

Joseph Parrocel, 1646–1704

The Hawking Party: An Allegory of the Continent of Asia (No. 6474)

Canvas, 110.5 × 106 cm.
Purchased 1982

The name of Joseph Parrocel is little known. If he is remembered at all, it is only as a painter of battles, particularly those commemorating the campaigns of Louis XIV. This hunt scene, one of a pair recently purchased by the Gallery, is a rarity among his works, and is so extraordinary in execution that one might be forgiven for associating it with the mid-eighteenth century or even the Romantic era of Delacroix. The handling is rapid and loose, with daring strokes of bright colour laid on with enormous freedom and vivacity. The novelty of Parrocel's work was early recognized. In the eighteenth century Papillon de la Ferté – who probably owned Fragonard's *Psyche* [Plate 40] – remarked, 'Parrocel is an innovator in everything he produces. Better than anyone he has known how to excel in effects of light, and in richness and variety of composition.'

What is most striking about this painting is how far it is removed from the austere idiom of French seventeenth-century classicism. There is none of the rigorous logic of classical composition; figures are arranged informally in groups of two or three on different levels, in contrasting poses. Instead of the crisp, sculptural modelling of classical painting, the figures are richly clad in brightly coloured costumes of violet and blue, and orange and red, which shimmer in the sunlight and softly disguise their forms. There is no high moral intent; the ladies and gentlemen relax from their sport and indulge in amorous flirtations. The setting is rural and picturesque; ruinous fountain and ancient, ivy-clad oak echo in their lack of regularity the pleasing informality of the figure group.

Nevertheless, for all this, *The Hawking Party* and its pendant *The Boar Hunt* were royal commissions. They formed part of a series of *The Four Continents* represented as hunts (two of which are lost), which with a *Fair at Bezons* were ordered from Parrocel by Louis XIV in the last years of the seventeenth century and given by him to his son the comte de Toulouse. They show decisively how *Rubénisme*, the taste for baroque movement, bright colour and informality of composition, had gained ascendancy over *Poussinisme*, or classicism. In this hunting scene, painted at the very turn of the century, and steeped in memories of Rubens and Veronese, we find an extraordinary prefigurement of Watteau's *fêtes galantes*, of his aristocratic lovers reclining in secluded parklands, suffused in the warm light of perpetual summer.

PLATE 29

Antoine Watteau, 1684–1721

The Scale of Love ('La Gamme d'Amour') (No. 2897)

Canvas, 51 × 60 cm.
Bequeathed by Sir Julius Wernher, Bt, 1912

At first sight it may seem that the work of Watteau contradicts the early-eighteenth-century desire for a more natural art and bears no relation to the real world. His shady woodlands peopled with elegant couples in costumes of silk and satin have often been regarded as the poetic fantasies of an invalid, alienated from the society of his age. It is true that tuberculosis caused Watteau's early death in 1721 and that in his time he was described as 'always discontented with himself and others', but his works enjoyed enormous popularity. For his contemporaries Watteau struck an authentically modern note in ignoring the tradition of history painting and substituting a new genre of his own making, the *fête galante*. This genre conforms to no established rules and deals not with heroes and unattainable ideals, but with situations and emotions common to all men, above all with human love and the pursuit of happiness. Like the theatre, Watteau's make-believe world is an easily grasped metaphor for reality and, as on the stage, dance and music are symbols for the harmonious union of couples.

Watteau came from Valenciennes in north-eastern France, which before his birth had been part of Flanders, and his roots are principally in seventeenth-century Flemish painting, in the rustic genre of Teniers and Brouwer, and in Rubens, whose Marie de Médicis series he studied in Paris. The influence of Venetian painting is also apparent in his evocative landscapes, in the play of light on rich materials, and perhaps most of all in the melancholy air of mystery that pervades his work.

In this picture a group of lovers stroll and recline in a secluded woodland scene, where an antique bust stands overgrown by foliage. Their colourful dress is fanciful, belonging to no particular period, and the setting is undefined, an enchanted realm of shady bowers and mossy banks. As in a Shakespeare comedy, the plot unfolds in no distinct place or time, and all the characters are preoccupied by love. The principal couple incline towards each other as they join together in song. The title, 'La Gamme d'Amour', comes from an engraving published in 1735 and reinforces the suggestion that the musical harmony of voice and guitar is intended as an outward sign of the union of lovers.

PLATE 30

Hyacinthe Rigaud, 1659–1743

Antoine Paris (No. 6428)

Signed indistinctly
Canvas, 144.7 × 110.5 cm.
Purchased 1975

Antoine Paris (1665–1733), comte de Sampigny and baron de Dagonville, was the eldest of four brothers who were celebrated financiers in Paris in the early years of the eighteenth century. They were sons of an inn-keeper in Moirans in the Dauphiné, and apparently made their fortune by getting supplies across the Alps to rescue the French army in Savoy. Antoine, known as Paris l'Aîné, rose to be put in charge of the commissariat of the French army in Flanders during the War of the Spanish Succession. Although not altogether trusted by the Regent, he was made 'Garde du Trésor Royal' and secretary of the Order of St Louis in 1722, and under the premiership of the duc de Bourbon (1724–26) reached the peak of his power. In the words of Saint-Simon, the Paris brothers became 'masters of the kingdom . . . [they] acquired immense wealth, made and ruined the fortunes of ministers and of others, and saw the court, the city and the provinces at their feet'. However, when Cardinal Fleury gained power in 1726 they were exiled, and Antoine died in exile in 1733 at his splendid residence at Sampigny in Lorraine.

Rigaud painted this portrait in 1724, when Antoine Paris was at his most powerful. By this stage of his career Rigaud had become leading court portraitist (in contrast to his friend and rival Largillière who found most of his clients among the wealthy bourgeoisie of Paris). He had painted all the Royal Family, including the young Louis XV, and many of the leading figures of Europe had also sat for him. Already in 1715 Rigaud had painted a half-length portrait of Antoine Paris, but the size and splendour of this later portrait is a reflection of his sitter's new pre-eminence, at the innermost circle of the court. Rigaud's *Livre de Raison*, the account-book he kept of his works, in fact records two three-quarter-length portraits of '*Mr. Paris l'aîné*' in 1724, one being this portrait, the other being a very similar painting but with the sitter shown full-face, in the Norton Simon Collection, Los Angeles. They are the only large-scale portraits Rigaud painted in that year, and he charged the high sum of 3000 *livres* each for them, another indication of the sitter's elevated status.

In creating this superb image of Paris, Rigaud has omitted any reference to his origins or his profession, and by using all the devices of baroque state portraiture – grand architectural embellishments, opulent draperies and grandiloquent gestures – he has conferred upon his sitter an air of aristocratic authority and *hauteur*. Only in the face, which is enlivened by an expression of humour and intelligence, is there an indication of the direction portraiture was to take in the eighteenth century, away from the grandiloquent rhetoric favoured by the court of Louis XIV, towards a greater naturalism and a concentration on character instead of on status.

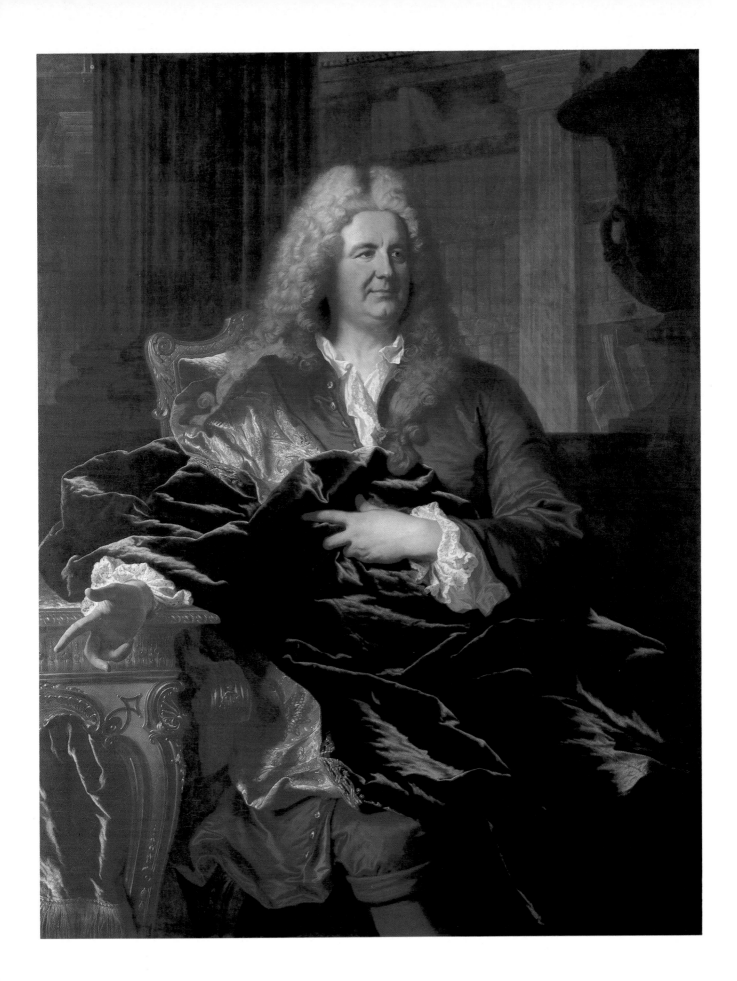

PLATE 31

Jean-François Detroy, 1679–1752

Time unveiling Truth (No. 6454)

Signed: DETROY 1733
Canvas, 203 × 208 cm.
Purchased 1979

In spite of the innovations of Watteau and his followers in terms both of subject-matter and handling, the traditional categories of painting continued to flourish in France in the eighteenth century. One of the most highly regarded and versatile artists of the early decades of the century was Jean-François Detroy, the son of the portrait painter François de Troy. He was capable of producing large-scale religious and mythological compositions as well as tapestry cartoons (see Plate 32) and small scenes of fashionable life (not dissimilar to those of Lancret and Boucher). He shared first prize with François Lemoyne in the royal *concours* of 1727, he received numerous commissions from the crown, and in 1738 he was appointed Director of the French Academy in Rome, a post he held until his death.

It is not known for whom this large allegorical composition was painted, although it is later recorded as belonging to the mother of Napoleon, Laetitia Bonaparte. Nevertheless, it is characteristic of a great part of Detroy's *œuvre* and also of French history painting in general at this period. The subject is traditional and occurs in painting at least from the sixteenth century; the treatment, however, is light and decorative.

Truth is represented as a beautiful young woman, simply adorned, whom the winged and bearded Time unveils. According to an ancient saying, '*Veritas filia temporis*', Truth is the daughter of Time, and is revealed by him. She stands with one foot on a globe, to indicate that she is above worldly things, while with her left hand she draws away a mask from an old woman who represents Deceit or Fraud. Beside her the four cardinal Virtues kneel in tribute to the revealed Truth: Prudence, who holds a snake in allusion to the biblical saying, 'Be ye wise as serpents'; Justice, carrying a sword, a symbol of power, and scales, symbolic of impartiality; Temperance, bearing a pitcher of water, signifying abstinence; and Fortitude, who is accompanied by a lion, symbol of courage.

Detroy has given his painting an antique character, appropriate to the dignity of his theme. His women are classically garbed and coiffed, and in the background is a temple reminiscent of the Pantheon in Rome. But we should not take all this too seriously. Detroy's characters are engaged in a charade. The ungainly figure of Time, the adoring, awestruck Virtues, and the lion licking its paw are faintly comical, and Truth wears a knowing smile as if to acknowledge that this is mere play-acting, a tableau created for decorative effect rather than for moral enlightenment.

PLATE 32

Jean-François Detroy, 1679–1752

Jason swearing Eternal Affection to Medea (No. 6330)

Canvas, 56.5 × 52 cm.
Bequeathed by Francis Falconer Madan, 1962

Once again, in this oil sketch, Detroy's treatment of his subject is little short of comical, and his intention entirely decorative. The painting is one of the *modelli* for a series of seven Gobelin tapestry designs on the story of Jason. The *modelli* were completed by 15 February 1743, and six of them including this, the first of the series, were in the Detroy sale in Paris in 1764. A set of the Gobelin tapestries were chosen in 1770 to decorate the pavilion at Strasbourg, when Marie-Antoinette arrived in France as bride of the Dauphin. Goethe saw them there and was horrified at the choice. 'Is there no one among the architects and decorators who understand that pictures represent something?' he exclaimed. But Goethe was of a new generation which demanded more of painting than pleasing effects. The violent and tragic story of Jason and Medea was certainly unfitting for a bride, but Detroy's treatment is light-hearted and fanciful, and entirely devoid of horror. Like actors on a stage, his protagonists strut and gesture to maximum effect without any real risk to body or soul.

According to the classical legend, as recounted by Ovid in book VII of his *Metamorphoses*, the Greek hero Jason was sent to steal the Golden Fleece, and was helped in several deadly tasks set him by the king of Colchis by Medea, a sorceress and daughter of the king. Jason tames the savage bulls, combats the soldiers born from a serpent's teeth, puts to sleep the ever-watchful dragon and wins the Golden Fleece. He marries Medea, but on reaching Corinth abandons her and takes the daughter of Creon as his wife. In her rage, Medea kills her rival with a poisoned robe and slaughters her own children.

These horrific incidents are rendered innocuous in Detroy's charmingly painted sketches. In this one, which is typical in its loose and fluent brushwork, Jason comes upon Medea at the altar of Hecate, hidden in the deep shades of a forest, and receives from her the magic herbs which will secure his life. Detroy follows closely Ovid's description of the passionate encounter: 'She gazed upon him and held her eyes fixed on his face as if she had never seen him before; and in her infatuation she thought the face she gazed on more than mortal, nor could she turn herself away from him. But when the stranger began to speak, grasped her right hand, and in low tones asked for her aid and promised marriage in return, she burst into tears and said: "I see what I am about to do, nor shall ignorance of the truth be my undoing, but love itself. You shall be preserved by my assistance; but when preserved, fulfil your promise." '

PLATE 33

Nicolas Lancret, 1690–1743

Morning from *The Four Times of Day* (No. 5867)

Copper, 28.5 × 36.5 cm.
Bequeathed by Sir Bernard Eckstein, 1948

This is the first of a series of four small genre paintings on copper representing the different times of day: *Morning, Midday, Afternoon* and *Evening*. Engravings of them were presented to the Académie in Paris by Nicolas de Larmessin IV in 1741, and this painting, *Morning*, was exhibited by Lancret at the Salon of 1739.

Although scenes of everyday life were common in Dutch and Flemish painting in the seventeenth century, they are almost non-existent in France before the eighteenth century, when Lancret was one of the first to depict contemporary manners in a natural and casual manner. In so doing he was answering a demand for a less pompous and affected art. The bourgeois society of the eighteenth century could no longer tolerate the formality and rhetoric of the arts as patronized by Louis XIV, and as the authority of the Académie and the Court slackened, so still-life, portraiture and genre were able to flourish alongside religious and historical painting.

Lancret's little breakfast scene is of no value or importance from a moral or religious standpoint. Indeed, the abbé is indulging a taste for the company of elegant ladies not quite compatible with his vocation. But the artist prefers to show human nature and natural affections as they exist rather than as they ought to be in a strictly moral society. In the eighteenth century women played a vital civilizing role in encouraging the arts and bringing new ease and informal grace to social behaviour.

The lady of the house is the leading character in Lancret's domestic drama. She occupies the centre of the stage and is the focus of everyone's attention, as she breaks from her morning toilette to pour coffee for the adoring abbé. They are seated in a comfortably furnished boudoir, the panelled walls of which are hung with landscapes and light-hearted mythologies. An elaborately carved clock tells us the hour, a few minutes after nine. The sofa is well upholstered and the dressing-table and door are hung with costly damasks. Four cups are laid for coffee, suggesting that the lady is expecting more than one visitor. But the maid's amused and knowing expression tells us that the abbé is a particular admirer of her mistress. His ardent manner, as he pays court to her, leaning forward in his chair, one hand eloquently gesturing, is sufficient to show us that he has lost his heart to her.

PLATE 34

Nicolas Lancret, 1690–1743

A Lady and Gentleman taking Coffee with Children in a Garden

Canvas, 89 × 98 cm.

(No. 6422)

Bequeathed by Sir John Heathcoat Amory, Bt, 1972

Lancret was trained like Watteau by the painter and engraver Claude Gillot, but the chief formative influence on his work was Watteau himself. Lancret shares his love of romantic parklands and hazy vistas, and his figures, like Watteau's, are delicate and refined, dressed in shimmering silks and satins. But while the older artist's work is steeped in a poignant melancholy that colours even his most animated compositions Lancret's is tender, light-hearted and innocent. His enchanted world is the Garden of Eden before the Fall.

However, Lancret's work is also distinguished by a greater degree of naturalism. In it the worlds of Watteau and Chardin seem to combine. His men and women are usually dressed in contemporary fashions, they partake of food and drink like ordinary mortals and have time occasionally for activities other than love-making.

In this touching scene, a pair of doting parents treat their daughters to a taste of coffee, as they partake of refreshment in a garden, beside an ornamental pond. The painting is traditionally called '*La Tasse de Chocolat*', but it was exhibited at the Salon of 1742, the year before Lancret's death, under the title *Une dame prenant du Caffé avec des Enfans*. The episode is touchingly observed. The younger child, who has a cloth tied round her to protect her dress, wears an expression of wide-eyed expectation as she prepares to drink from the spoon offered to her by her mother, while the father looks on indulgently. A doll lies discarded nearby and a dog roots among the hollyhocks. Lancret has surely here depicted a real family – the work was no doubt commissioned – but the setting is entirely fanciful. The domestic vignette is grafted on to a fantastic background of fountains, urns and trees. This is not the clipped and regimented parkland which customarily bordered a gentleman's house. Here nature runs riot and is allowed to infiltrate the ordered realm of man's domestic routine, bringing with it, like a breath of fresh air, a new note of warmth and informality.

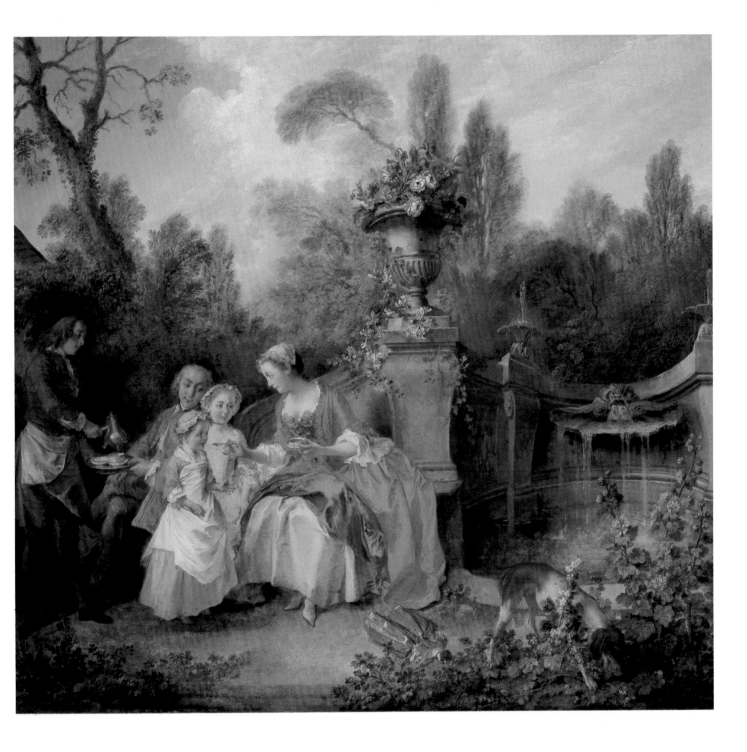

PLATE 35

Jean Siméon Chardin, 1699–1779

The Cistern (No. 1664)

Canvas, 37.5 × 44.5 cm.
Purchased 1898

French eighteenth-century painting is most noted for its light-hearted scenes of dalliance, for its gods and goddesses, shepherds and shepherdesses, engaged in amorous sport in flower-decked bowers or boudoirs. Nothing could be further removed than Chardin's sober, domestic world of kitchen interiors and modest still-lifes. Yet Chardin was greatly admired by his contemporaries and enjoyed a long and successful career. He was elected to the French Académie as a young man, he regularly exhibited at the Paris Salon, his paintings were sought by all society, including the King, and, through engravings, reached a wide audience.

Clearly Chardin touched a nerve of his time, quite as keen and alive as the taste for playful mythologies and colourful decorations. He appealed to the eighteenth-century regard for simple truth, for duty and morality, and for basic human affections and sentiments. His world is entirely domestic. Virtually the entire repertory of his themes might be found under one roof, within a respectable and pious Parisian household: the pots and pans of the scullery, the game and vegetables of the larder, the fruit and cheeses, and the fine glass and china of the dining-room; together with the industrious cast that bring life to the lovingly depicted interiors: the scullery maid, the laundress, the governess, the invalid, the nurse, the mother, and the boys and girls who play and study, ask questions or are instructed by their elders. A whole world of relationships and obligations, of affections, memories and sorrows lies behind Chardin's paintings, each of which is like a window offering a glimpse on a part of it. Chardin takes the part of a passive but feeling observer, discreetly recording the simple facts of bourgeois life with deep respect for his subjects and with the intimate knowledge of one accustomed to domestic routine.

Several versions exist of this composition, one of which is dated 1733. The subject is a very ordinary event in a very humble part of the house. Within a cobbled scullery a maid draws water from a copper cistern. But, in spite of the commonplace nature of his subject, Chardin depicts every detail with careful regard to truth. The copper pots and the cistern itself are already familiar to us from still-lifes in which they feature. In the background a door leads into a further part of the house where a woman stops to talk to a child, an intimation of the involvements that exist just beyond the orbit of this picture.

Meanwhile, her cap shading her face from view, the maid remains anonymous, yet her pose as she patiently bends to fill the jug is expressive of a natural dignity. The roots of Chardin's art may be in seventeenth-century Dutch genre painting, but the spirit that instills it looks back to the Le Nain brothers and anticipates Millet's sensitive depictions of peasant life of a century later.

PLATE 36

Jean Siméon Chardin, 1699–1779

The Young Schoolmistress (No. 4077)

Signed: Chardin
Canvas, 61.5 × 66.5 cm.
John Webb Bequest, 1925

Children play a special part in Chardin's world. He devotes to them a whole category of his work in which they are shown almost as large as life, playing at shuttlecock, blowing bubbles, spinning a top, sketching with chalks or building a house of cards (Plate 37).

Stemming out of his genre scenes of domestic life, these pictures concentrate on one or two faces, and provide a more intense study of character. They are nevertheless not portraits, although each child is individual and clearly drawn from life. The young sitters never confront the artist, but are engrossed in their own thoughts and pursuits. Chardin's understanding of this childish self-absorption is fundamental to his penetrating portrayal of children. Through the faithful depiction of a familiar or trivial activity, he captures the essence of a child's outlook on the world, and by fondly delineating the gestures, expressions and postures of his young subjects he reveals their thoughts and feelings.

This rare quality of Chardin's paintings was grasped in his own time. When *The Young School-mistress* was shown at the Salon of 1740, perhaps a few years after it was painted, one critic remarked, 'What elegance, what spontaneity, what truth! The viewer feels more than he can say.' Later that year Lépicié published an engraving of the painting with a caption reading:

If this charming child takes on so well
The serious air and imposing manner of a
 schoolmistress,
May one not think that dissimulation and ruse
At the latest come to the fair sex at birth?

The note of anti-femininity apart, Lépicié nevertheless grasped in the enquiring tilt of the elder girl's head, her interrogative glance, and the assurance of her precise gestures the commanding air of a precocious young instructress. A little play is being performed before our eyes in which the elder child lords her greater knowledge and experience over the bewildered and guileless infant. On one face we read shrewdness and impatience, as the schoolmistress instinctively apes behaviour she has observed in her elders; on the other, the plump babyish features betray an inward struggle with the mysteries of learning.

But Chardin's chief regard is with truth, not with moral instruction. His loving scrutiny extends to every object and every surface, capturing in thick granular paint the warm tone of the cabinet, the gleam of light on a metal pin and a key, and the heavy weight of the caps and bodices. Through his eyes we see these children with the affection of familiarity and with a sense of their youthful innocence that far outweighs the mimicry of adult behaviour.

PLATE 37

Jean Siméon Chardin, 1699–1779

The House of Cards (No. 4078)

Signed: chardin
Canvas, 60 × 72 cm.
John Webb Bequest, 1925

This picture was exhibited at the Paris Salon of 1741 under the title 'The Son of M. Le Noir amusing himself by making a House of Cards'. M. Le Noir was a Paris furniture dealer and cabinet maker, and a close friend of Chardin. In 1742 Chardin had exhibited a portrait of Le Noir's wife holding a book, and it has been suggested that *The Young Schoolmistress* (Plate 36) (which also came to the Gallery from the John Webb collection) may represent other children of Le Noir.

The House of Cards differs from *The Young Schoolmistress*, however, in showing one figure only, absorbed in his game, and in being yet more economical in design. The young boy with his three-cornered hat and long hair tied back in a bow is silhouetted against the neutral ground of a stone wall. The only other major element in this spare composition is the card-table, its drawer open, from which the boy has extracted the pack of cards with which he carefully builds his fragile construction. Yet the attitude of the boy and the distribution of these few simple items are everything. With these slight means Chardin achieves an extraordinary balance of composition, and harmony of colour and tone.

The theme of a child constructing a house of cards must have appealed to Chardin since he painted several versions of the subject, this being the latest in date and the finest in quality. The theme is in fact not original. It was treated by several of Chardin's contemporaries and was thought to signify the transience of worldly things. The fragility of the boy's house of cards which is doomed to collapse is a symbol of the vulnerability and vanity of man's creations. The message is made quite clear in the caption to Lépicié's engraving of the picture, published in 1743:

> Charming child, pursuing your pleasure,
> We smile at your fragile endeavours,
> But, in confidence, which is more solid
> Our projects or your house?

But for Chardin and for his audience the significance of the subject, being so familiar, could be taken for granted. The theme is a pretext for a brilliantly natural and intimate piece of observation. What is unique to Chardin is his ability to portray children, in this case the son of a dear friend, without sentimentality or condescension, and with a rare understanding of the freshness of their response to the familiar objects of everyday life.

PLATE 38

François Boucher, 1703–1770

Landscape with a Water-mill (No. 6374)

Signed: f. Boucher / 1755
Canvas, 57.2 × 73 cm.
Purchased 1966

For Boucher's aristocratic patrons, his rustic landscapes, in which plump peasants happily pursue their daily tasks among tumbledown cottages and mills, offered a delightful escape into a fantasy world where hunger was unknown and the sun always shone. Marie-Antoinette and her ladies at the court carried this charade further and themselves played at milkmaids and shepherdesses in the *hameau*, a picturesque village of cottages and farm buildings, specially constructed for their amusement in a corner of the park at Versailles. In view of what is known of the real state of the peasantry, it is difficult not to condemn the heartless cynicism of the aristocracy, who blinded themselves to the poverty and suffering around them and, secure in their privilege, affected the simplicity of rustic life.

But should we likewise condemn Boucher? He is not alone in his idealization of poverty and deprivation. Gainsborough achieved great success with his so-called 'fancy' pictures, paintings of peasant families and beggar children, part of the attraction of which was to wring the hearts of the affluent with worthy sentiments of sympathy and compassion. In Boucher's arcadian idyll, however, there is little overt appeal to such sentiments. His peasant folk may be poor and ragged, but they are contented and robust enough to care for themselves. They neither seek our patronage nor call for us to indulge in hypocritical pity. Boucher's only crime, if crime it be, is to shun reality and create instead an enchanted vision of rural life, from which all cares are banished. There is no disease, no privation and no ugliness. Labour is a joy, and man and nature co-exist in perfect harmony.

It is impossible not to be beguiled by so attractive an invention. In Boucher's fictitious world there are no masters and no laws. His unaffected peasant stock pursue their natural inclinations, caring for their families, their animals and themselves, in a world unspoilt by their presence. They and the objects of their creation – the mill, the lock, the bridge – merge with nature in a picturesque and haphazard ensemble. Beguiling, too, is the way in which Boucher conjures up his vision. Everything seems imbued with a rich and fecund vitality. The abundant foliage of trees and bushes froths and surges into the sky, old thatched roofs, stone walls and wooden posts sag and bulge like living things, and the sunlight sparkling on every surface makes the whole canvas shimmer.

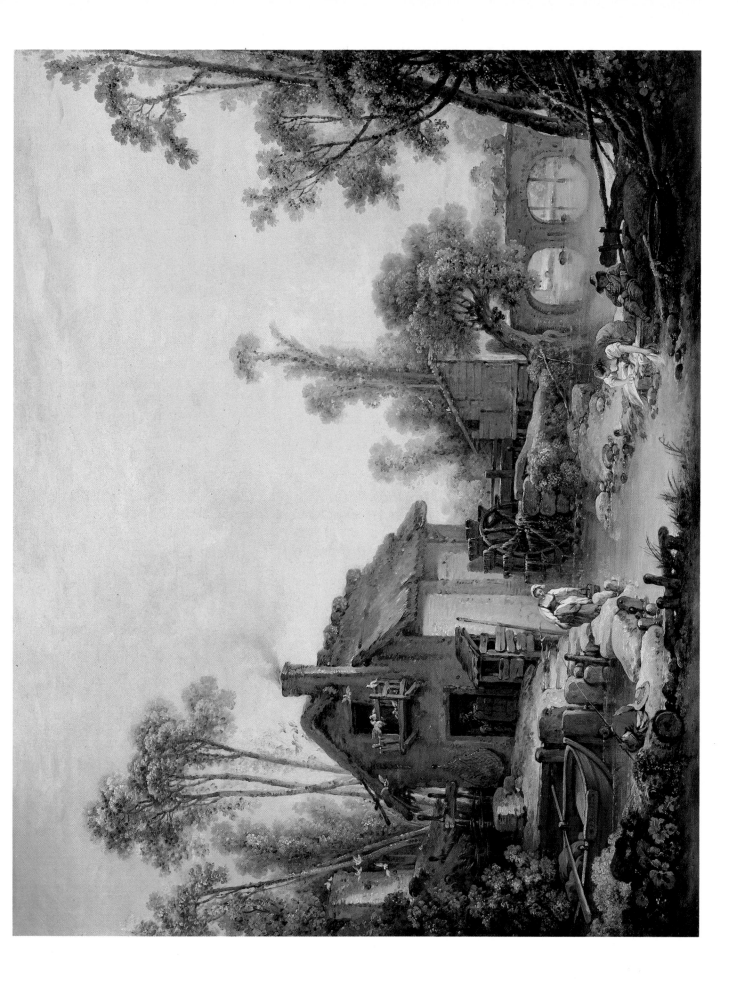

PLATE 39

François Boucher, 1703–1770

Pan and Syrinx (No. 1090)

Signed: f. Boucher / 1759
Canvas, 32.5 × 41.5 cm.
Presented by Mrs Robert Hollond, 1880

The story of Pan and Syrinx is told by Ovid in his *Metamorphoses*. The wood-nymph Syrinx is pursued by the god Pan, and arriving at the banks of the River Ladon begs the nymphs of the stream to change her form, whereupon she is transformed into reeds: 'Pan, when now he thought he had caught Syrinx, instead of her held naught but marsh reeds in his arms; and while he sighed in disappointment, the soft air stirring in the reeds gave forth a low and complaining sound. Touched by this wonder and charmed by the sweet tones, the god exclaimed, "This union, at least, shall I have with thee." And so the pipes, made of unequal reeds fitted together by a joining of wax, took and kept the name of the maiden.'

This touching story is, for Boucher, little more than a pretext for the depiction of a scene of sexual pursuit. By representing the River Ladon as a nymph he capitalizes on the story, giving himself the opportunity to paint two delectable nudes instead of one. The risk of ravishment still seems ever present. Although, in accordance with the story, Pan grasps an armful of reeds, the lovely Syrinx shows no signs of shaking off her fleshly form and looks over her shoulder with a coy expression of encouragement.

Boucher's enormous success was largely due to his ability to strike the right note of carefree hedonism, almost regardless of his theme, although towards the end of his career, as the mood of the times changed, his lack of proper moral feeling won him the strictures of Diderot. But he was also a technician of enormous virtuosity and, in spite of its small size, this canvas shows his art at its finest. Several preparatory drawings survive, proving that he took particular care over it. He depicts the excitement of the pursuit in a composition based on diagonals: Pan descends on the two nymphs who form one sinuous flowing form across the lower right corner of the picture, while the dramatic zigzag motion is echoed in the darting cupids, one of whom brandishes an arrow and a flame, symbols of passion, and in the haphazard pile of rocks and branches above. Boucher effectively contrasts the bronzed muscular torso of Pan with the softly swelling forms of the girls. He is a master at manipulation of paint, and with creamy touches of highlight and delicately blended cross-hatchings he manages to suggest the youthful and erotic bloom of their bodies. The brilliant white and blue of the draperies and the greens of the reeds offset the delicate flesh pinks, and small touches of bright pigment on leaves and flowers give a sparkling vitality to the whole canvas.

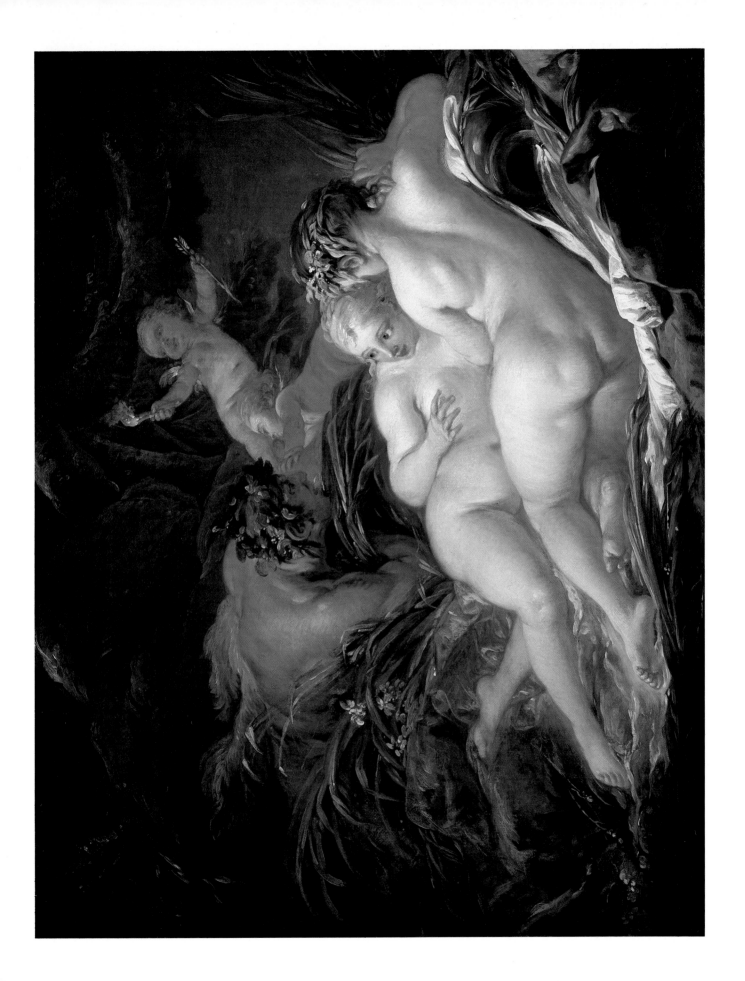

PLATE 40

Jean-Honoré Fragonard, 1732–1806

Psyche showing her Sisters her Gifts from Cupid (No. 6445)

Canvas, 168 × 192 cm.
Purchased 1978

Until 1977, when the late David Carritt identified it as a missing Fragonard, this painting languished on the walls of Mentmore Towers, dirty and unrecognized. In the Earl of Rosebery sale at Mentmore in May 1977, it was mistakenly catalogued as a *Toilet of Venus* and attributed to the largely forgotten Carle Van Loo. However, it was known that, while he was a student at the Ecole Royale des Elèves Protégés in Paris, Fragonard had painted a large canvas of Psyche with her sisters, which was included in January 1754 in an exhibition of pupils' work in the King's apartments at Versailles, and seen there by Louis XV. It featured in 1797 in a sale, attributed to the school of Boucher, and subsequently disappeared. Although David Carritt suspected that the 'Carle Van Loo' was Fragonard's missing canvas when he purchased it at the Mentmore sale, he could not be certain until the layers of dirt and discoloured varnish had been removed. Only after cleaning did the superb quality of the colour and handling become evident. Comparison with *Jereboam sacrificing to the Idols* (The Louvre, Paris), which Fragonard had painted in 1752, the year before *Psyche*, reveals striking similarities of composition and treatment, and demonstrates conclusively that it is the work of Fragonard.

The painting has been slightly cut down but in general is well preserved. It is perhaps not surprising that its identity should have been lost, since Fragonard was only twenty-one when he painted it, and his style was still very much influenced by Boucher, under whom he had studied for four years.

The sharp profile of Psyche, seated on the right, and the smooth, porcelain-like treatment of the flesh, is particularly reminiscent of his master. The diaphanous, pastel-coloured draperies and sweeping rhythms, especially in the attendant dressing Psyche's hair and the swirling *putti* above, are, however, entirely characteristic of Fragonard, and make this his first masterpiece.

Boucher's influence can also be traced in the subject. In 1739 he had produced a series of tapestry designs on the story of Psyche, some of which bear a strong resemblance to Fragonard's composition. Natoire had also painted a series of decorations treating the subject at the Hôtel de Soubise in Paris, and in 1751 the story was taken by Blaise as the theme of a ballet.

The story of Cupid and Psyche is told originally by the Roman writer Apuleius in his *Metamorphoses* or '*Golden Ass*', but Fragonard was probably acquainted with it through La Fontaine's version. The god Cupid falls in love with Psyche and takes her to his magical palace. He conceals his identity and, forbidding Psyche to look at him, visits her only at night. In Fragonard's picture she is portrayed showing the rich gifts she has received from Cupid to her two sisters. In their jealousy they try to wreck Psyche's happiness by persuading her that her lover must be a monster. At night she takes a lamp to look on him; he awakes and abandons her. In the painting Fragonard has depicted one of the Furies, serpent-haired, hovering above the sisters and inspiring them with envy.

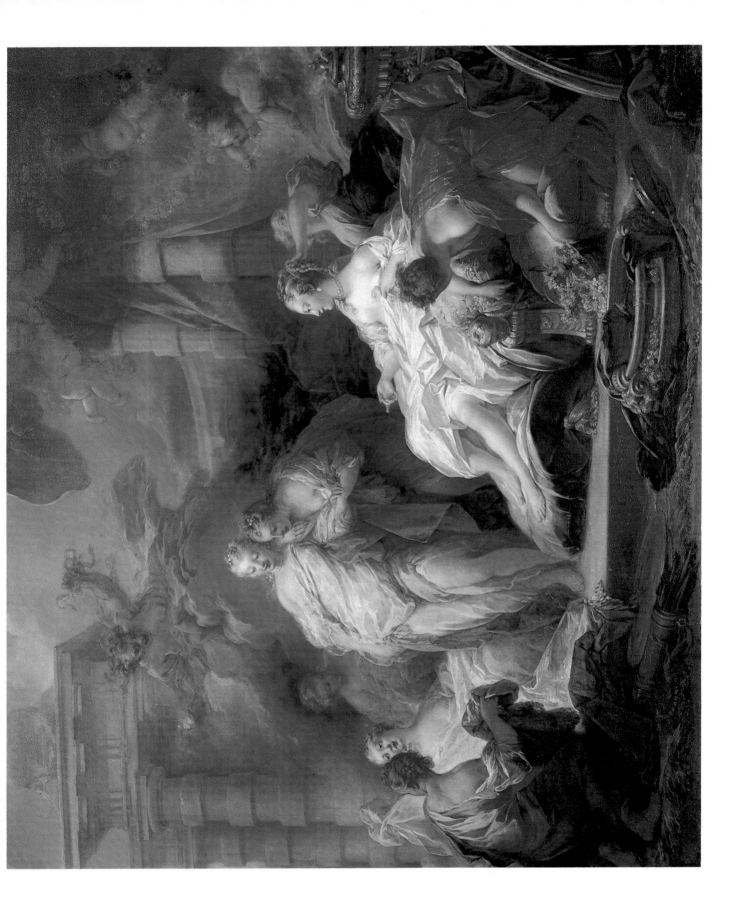

PLATE 41

Jean-Marc Nattier, 1685–1766

Manon Balletti (No. 5586)

Signed: Nattier. p.x. / 1757
Canvas, 54 × 45.5 cm.
Bequeathed by Miss Emilie Yznaga, 1945

Successor to Rigaud as leading court portraitist was Jean-Marc Nattier. His father had been a portrait painter, and as a young man he received encouragement from the aged Louis XIV when he presented to him his drawing of Rigaud's full-length portrait of the King of 1701, intended for the engraving. 'Monsieur, continue to work like this, and you will become a great man,' the King is supposed to have said to him.

Nattier's reputation, however, was based on his portraits of Louis XV, his Queen, Marie Leczinska, and their daughters. It was as a painter of women above all, that he excelled. At the time of the Salon and their daughters. It was, above all, as a painter of women that he excelled. At the time of the Salon as well as for their lively handling. He continued the aristocratic tradition, practised by, among others, Mignard (Plate 27), of portraying his sitters as classical goddesses, against a conventional backdrop of columns and curtains – a practice which late in his career appeared out-of-date, and earned him the censure of the critics. But, while failing to present character seriously, Nattier was nevertheless skilled at catching a likeness and responsive to vivacity and charm, achieving a sense of ease and intimacy in spite of allegorical accessories.

Both vivacity and charm are evident in this enchanting late portrait of Manon Balletti, which is probably the portrait of her which Nattier showed at the 1757 Salon. Marie-Madeleine Balletti, as she was baptized on 4 April 1740, was the daughter of Sylvia Balletti, a well-known actress in the Italian company in Paris. She became acquainted with the notorious Casanova when he arrived in Paris in 1757, and it was probably Casanova, who had a high regard for Nattier's work, who arranged for her portrait to be painted. The artist has here dispensed with all the mythological trappings of his court portraits, and retaining only the simplest of accessories – a silk veil, a pearl brooch and a rose – has concentrated his attention on the beauty and freshness of his young sitter. Her liaison with Casanova continued for about three years, but on 20 July 1760 she married the architect Jacques-François Blondel. She died in 1776.

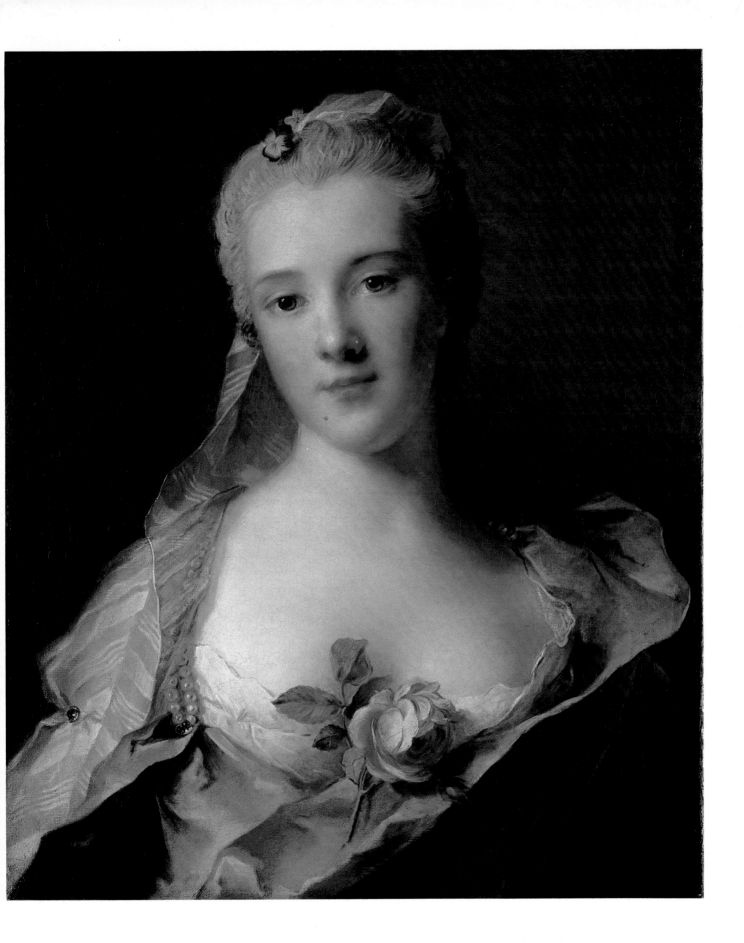

PLATE 42

Maurice-Quentin de La Tour, 1704–1788

Henry Dawkins (No. 5118)

Pastel on paper mounted on canvas, 66.5 × 53 cm.
Bequeathed by C. B. O. Clarke, 1940

Portraiture was dominated during the middle years of the eighteenth century by the witty and eccentric figure of Maurice-Quentin de La Tour. Among his portraits, which are executed in pastel, are images of many of the most famous figures of the day – Voltaire, Crébillon, Rousseau, Madame de Pompadour, various members of the royal family and the court, and artists such as Chardin and Restout.

It seems that he was persuaded to take up pastel by the success of the Venetian pastellist Rosalba Carriera, when she visited Paris in 1720–21, and he achieved a peak of technical accomplishment in that medium which has seldom been matched. He almost invariably adopts a small, bust-length format, portraying his sitter against a plain ground. With the minimum of accessories, he thus focuses on the face and features, creating the most astonishingly lifelike effects. In the museum at La Tour's birthplace, Saint-Quentin, are preserved dozens of pastel portrait-sketches, or *Préparations*, where disembodied faces, incompletely drawn, emerge with uncanny vitality, smiling out of the paper. Like Chardin, La Tour seemed to his contemporaries a kind of magician, capturing the living presence of his subjects, without any of the adornments of art.

In this portrait of Henry Dawkins (1728–1814), which probably dates from the 1750s, La Tour is more restrained than usual and refrains from the rather exaggerated vivacity that he sometimes confers upon his sitters. Nevertheless, he has conveyed in Dawkins' expression a note of wry amusement which lends animation and interest to the portrait. Dawkins was Member of Parliament for Southampton for many years, and La Tour succeeds in capturing the confident air of a gentleman of importance.

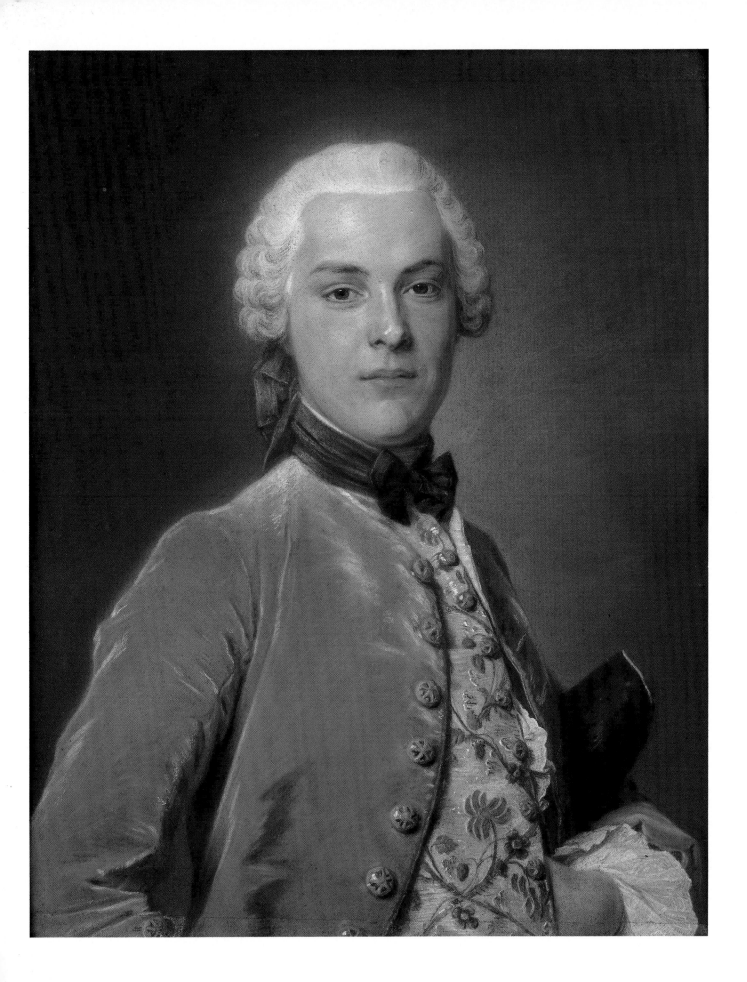

PLATE 43

Jean-Baptiste Perronneau, 1715(?)–1783

Jacques Cazotte (No. 6435)

Signed: Perronneau
Canvas, 92 × 73 cm.
Purchased 1976

As a portraitist Perronneau had the misfortune, in France at least, of being overshadowed by the flamboyant and self-advertising Maurice-Quentin de La Tour. Perhaps because of this, he travelled extensively after 1755, visiting Italy and Holland and, later in life, Russia. He died in Amsterdam, where he had frequently worked.

While, like La Tour, Perronneau worked in pastel, he also excelled in oils, usually eschewing in his portraits the glamorous effects and flattering charm beloved by La Tour, and achieving a sharper and more pungent sense of character. Nowhere is this penetrating observation more apparent than in the brilliant portrait of Jacques Cazotte, possibly his masterpiece. Like La Tour, Perronneau eliminates all inessentials, and shows his sitter standing in a bright coral coat against a plain olive-green background. The handling is rapid and lively, with the highlights on velvet and lace fluently brushed in, yet the head is modelled with the utmost care. The rendition of Cazotte's face and expression must rank among the finest achievements of portraiture – and not only in the eighteenth century. The bloom and texture of the skin are extraordinarily convincing. The twist of the mouth, the tilt of the nose and the glint of the eyes convey an impression of shrewdness and wit that seems to typify the intelligent and sceptical spirit of the century.

As his portrait suggests, Cazotte himself was a remarkable man. Born in Dijon in 1719, he obtained a public appointment in the naval administration and from 1747 until 1759 (except for a period of leave in France from 1752 to 1754) served in Martinique. But his chief interest was literature, and he turned his hand to verse, romantic novels, comic operas, and translations of oriental tales. He wrote parodies of Voltaire and was noted for his wit and speed of composition. After the death of his brother he inherited an estate at Pierry near Epernay in Champaigne, where he settled in 1760. Perronneau's family had property in the same area, and the artist probably met and came to paint him there. A royalist by conviction, Cazotte was appalled by the outbreak of the Revolution, and out of habit committed his views to paper. In August 1792 compromising letters were discovered, and Cazotte was arrested. He narrowly escaped assassination by revolutionaries at the beginning of September only to be summarily tried and guillotined on 25 September. From the scaffold he announced to the crowd: 'I die as I have lived, faithful to God and to the King.'

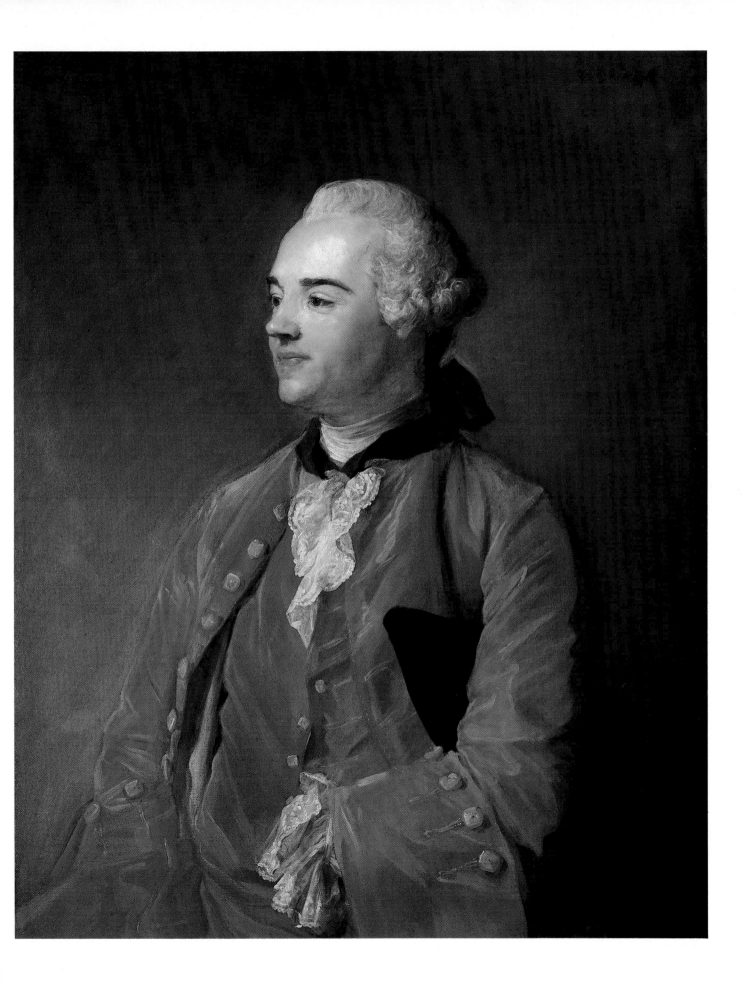

PLATE 44

Jean-Baptiste Greuze, 1725–1805

A Girl (No. 1019)

Canvas, 47 × 39 cm.
Wynn Ellis Bequest, 1876

During the second half of the eighteenth century in France, the delightful and indulgent view of life propounded by Boucher and Fragonard was to be challenged and overtaken by a new emphasis on morality – not the conventional religious morality of the seventeenth century, but a morality based on feeling. The change is signalled in the famous appeal of the writer Diderot to artists: 'First of all move me, surprise me, rend my heart; make me tremble, weep, shudder; outrage me; delight my eyes afterwards if you can.' The artist above all others who responded to this appeal was Greuze. His realistic genre scenes satisfied the public demand for an art that would tell moving stories of domestic piety and filial devotion, and confirm the sentimental belief that where the heart ruled, virtue and happiness reigned.

The subjects Greuze chooses for his large set-pieces are emotionally loaded, so to speak. They include a village betrothal, a paralytic surrounded by a loving family, a father blessing his son, a woman of charity visiting the sick and, in marked contrast, the return of a drunken father, and the curse of a father on his disobedient son. Another speciality of the artist is paintings of single figures, in which a moral lesson is similarly given heavy emphasis. Tender, adolescent girls are shown swooning with emotion over a pet dog or a dove, or tearfully lamenting a basket of broken eggs or a smashed mirror. One senses that for Greuze as for his public, however, the real attraction was the implied lapse from virtue (together with the delectable sensuality of the young malefactors) and not the moral lesson at all. Greuze's reputation has greatly suffered from the countless simpering, swooning, and slackly painted young girls he turned out, mostly in his later years.

This small head of a girl, however, is neither slackly painted nor sentimental. The polished handling of the flesh and the lively treatment of the features are a reminder of how fine a portraitist Greuze could be, capable of strong naturalistic observation. The firmness of the modelling, the delicacy of the colouring and the creamy impasto on the chemise, all indicate an early date, in the 1760s or 1770s, close to some of his best portraits, and show how much Greuze imbibed from Chardin, in terms both of subject and of handling. But, in spite of its touching depiction of character, this picture does not seem to be a portrait. With one arm raised, in the kind of rhetorical gesture commonly used by Greuze in his genre paintings, the girl would seem to be a study, albeit a very fine and finished one, for a larger composition.

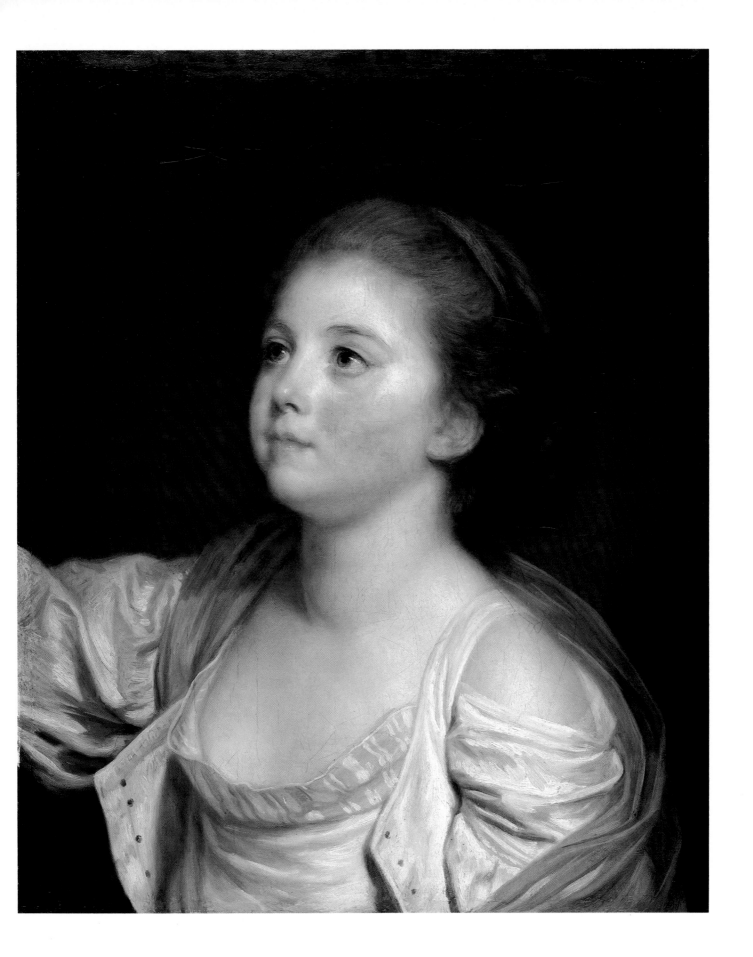

PLATE 45

François-Hubert Drouais, 1727–1775

The Comte de Vaudreuil (No. 4253)

Signed: Drouais le fils. 1758.
Canvas, 225 × 161 cm.
Presented by Barons Emile-Beaumont d'Erlanger, Frédéric d'Erlanger and Rodolphe d'Erlanger, 1927

When Drouais succeeded to Nattier's place as favourite court portraitist, he fully exploited the new cult of simplicity and naturalness by depicting aristocratic children as beggar-boys and gardeners – a device in its way as artificial as the mythological guise of Nattier's sitters. This portrait of the youthful comte de Vaudreuil, which may have been shown at the Salon of 1759, is hardly so extreme, and may to modern eyes still seem formal. and courtly. Even here, though, in the aristocratic full-length portrait, the stiffness of court etiquette begins to unbend a little under the relaxing influence of nature.

Joseph-Hyacinthe-François de Paule de Rigaud, comte de Vaudreuil (1740–1817), was son of the Governor of Santo Domingo, a French colony in the West Indies. He was born in the town of Santo Domingo, which explains why he is shown pointing to it on the map. During the Seven Years War he acted as aide-de-camp to the prince de Soubise, and the map of Germany in front of which he stands is presumably included as an allusion to the military commission he is about to undertake there. The martial flavour is reinforced by the armour lying on the floor at his feet.

How very unmilitary the young comte seems, though, standing at a slight tilt in his richly decorated velvet coat and waistcoat! Gracefully pointing to the map, and gazing out at the spectator with a passive expression of refinement, he seems scarcely yet a man. The armour at his feet has a comical, theatrical quality, as though, empty and discarded, it is intended to symbolize the rejection of warfare for the peaceful pursuits of civilized life.

The arts were certainly more to the taste of the comte than war and military glory. At court he became a noted patron of artists and a close friend of the woman painter Elizabeth-Louise Vigée Le Brun (see Plate 49). The impression given by Drouais' portrait is entirely confirmed by the account of Madame Le Brun, according to whom the comte possessed 'every quality and grace which can render a man attractive. He was tall, well made, and bore himself with remarkable nobility and elegance. His expression was agreeable and refined, his countenance as mobile as his ideas, and his kindly smile prejudiced one in his favour at first sight.' She takes pains to stress that, while the comte occupied so distinguished a position at court, his inclination was for the simple, unaffected life. 'He was, from his charming disposition, a child of nature, which he loved, and from which he got much too little enjoyment; his rank kept him away too often from a world towards which the soundness of his understanding and his taste for the arts attracted him incessantly.'

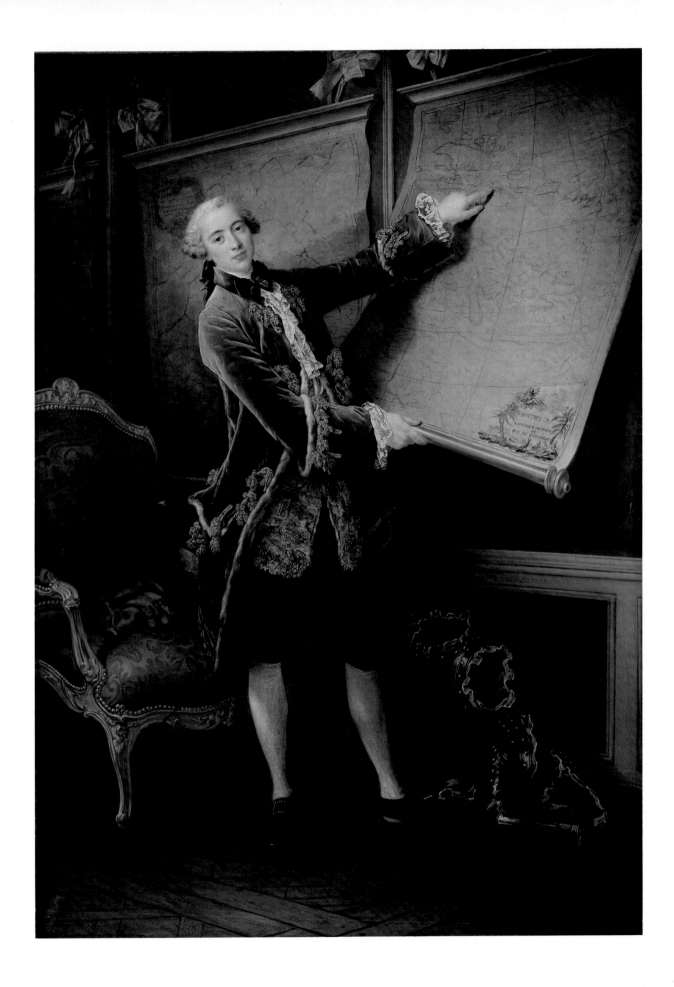

PLATE 46

François-Hubert Drouais, 1727–1775

Madame de Pompadour (No. 6440)

Signed: Peint par Drouais le fils / la tête en avril 1763;
 et le / tableau fini en mai 1764.

Canvas, 214 × 157 cm.

Purchased 1977

For all its apparent grandeur and assurance, there is a poignancy about this portrait of Madame de Pompadour, the mistress of Louis XV. As Drouais' inscription, neatly inset in the ornate work-table, tells us, the painting was begun in April 1763 but not completed until May 1764, a month after the death of the marquise. In fact, close examination shows that the head is painted on a separate piece of canvas which has been carefully incorporated into the full-length portrait. It was not uncommon, particularly with sitters of importance, for painters to adopt the practice of recording the features of their subject from life on a small, easily portable canvas, and then to work up the rest of the portrait in the studio probably with the help of a model. The sitter would lend a dress and probably one or two accessories, but would not herself be inconvenienced by long and tedious sittings. We are told that Madame de Pompadour died from a 'maladie de langueur', probably a long-drawn-out disease which would have prevented her playing a very active part in the production of the portrait.

Drouais' painting is nevertheless the grandest image of Madame de Pompadour and the most naturalistic. One contemporary, who saw it in Paris at the Palais de Tuileries in August 1764, remarked on the likeness. 'The resemblance is most striking and the composition of the picture is as rich as it is well arranged.' It is certainly a most up-to-date image, combining an appropriate degree of grandeur with a naturalness and a fidelity to appearances relatively new to French portraiture. Earlier in the century, Nattier had depicted the ladies of the court in the guise of nymphs and goddesses; Drouais, on the other hand, has shown one of the most celebrated ladies of the day working at a tapestry frame. Her pet dog Bébé, a black *espagnol*, is at her side, and around her a mandolin, wools and chalks, books and drawings bear witness to her many talents and pursuits. Industrious and intelligent, she exudes an almost homely air with her lace cap and benign expression.

Jean-Antoinette Poissin was born in 1721 and in 1741 married Charles-Guillaume Le Normant d'Etioles. In 1745 she became Louis XV's mistress and marquise de Pompadour, and in this role inspired the King with a mania for building, encouraged the Sèvres porcelain factory and played an influential part in government and public affairs. In matters of fashion she was a leader of taste, and as a patron of the arts she supported, among others, Boucher and Voltaire. In Drouais' portrait she is shown in her apartments at Versailles, and although by this time she had ceased to be the King's mistress and had lost her powerful position as intimate and confidante, she still retained great authority. The flattering air of matronly simplicity is, of course, affected and is nicely counterbalanced by the extravagance and show of the ornate furnishings and the richly embroidered dress.

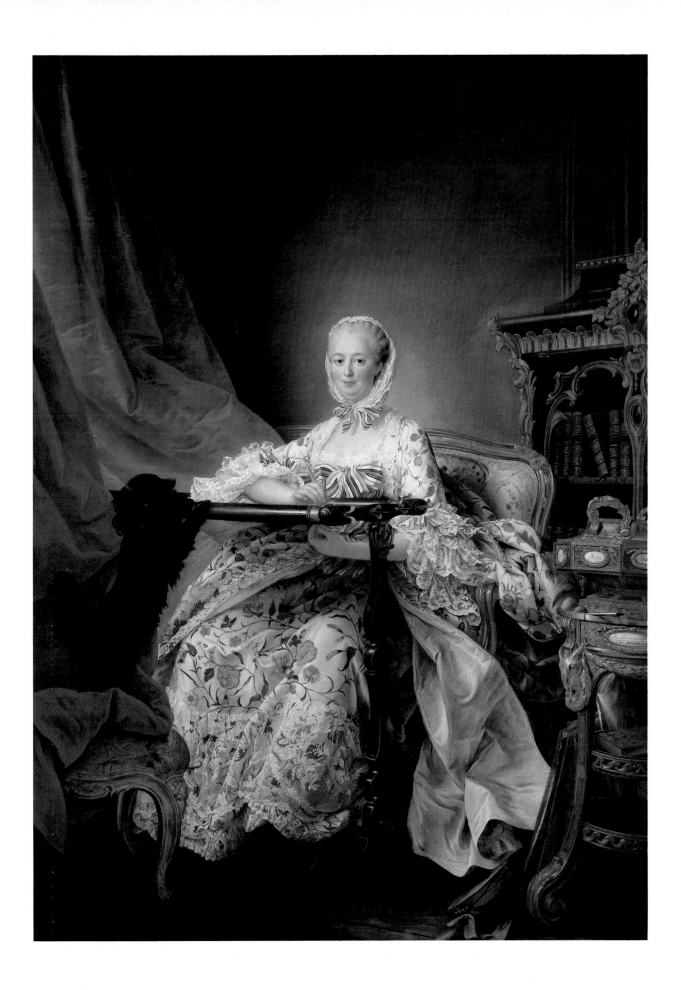

PLATE 47

Gabriel-Jacques de Saint-Aubin, 1724–1780

A Street Show in Paris (No. 2129)

Canvas, 80 × 64 cm.
Purchased 1907

Although he is not well known, and his paintings, at least, are rare, Gabriel de Saint-Aubin is one of the most attractive and original artists of his century. He failed several times to win first prize at the Académie, and became instead a member of the Académie de Saint-Luc where he exhibited his paintings. But his lack of success obliged him to devote his energies to graphic work. He earned his living from etchings and engravings, and illustrations to books.

In this respect his career parallels that of the nineteenth-century artist, Honoré Daumier. Like Saint-Aubin, Daumier had ambitions to be a painter, but made his name as an illustrator and caricaturist. Just as Daumier drew and painted the everyday life of Paris, satirizing the fashions of the day and demonstrating compassion for the poor and oppressed, so Saint-Aubin with similar verve and humour made sketches of the Parisian scene and contemporary manners: visitors to the Salon exhibitions and to shops and theatres, the life of the boulevard and domestic interiors. He even annotated, most usefully, the pages of his Salon catalogues with sketches of the exhibits.

This rare painting, which dates from 1760 and was entitled by the Goncourt brothers '*La Parade du Boulevard*', is typical in its choice of subject and in its lively handling of Saint-Aubin's spirited treatment of the contemporary scene. As in the case of Daumier, the professional illustrator's eye finds themes to exploit in areas of life completely neglected by painters of stature. Beneath the arching trees bordering a Parisian street, a whole cross-section of society strolls in the sunshine, or stops to take in a street show – portly gentlemen, old women, mothers with children, and from an upper window, and leaning against a tree, ladies of breeding who have the refinement not to make a vulgar display of their emotions. All eyes are turned on the mock duel – the same crude melodrama of the popular theatre that delighted Daumier. And, like his nineteenth-century successor, Saint-Aubin simplifies and exaggerates forms, enlivening his scene with his bold and expressive drawing, and introducing lifelike and poignant vignettes, like the little child who tries desperately to distract his mother from the young beau who leads her away, and the sleeping boy astride a bass drum. But Saint-Aubin looks back as well as forward. His genre is enchanting as well as amusing. The flicker of light and shade, the delicate brushwork and the charming colour, no less than the elegant postures of the lovers ambling beneath the trees, recall the *fêtes galantes* of Watteau and the rococo fantasies of Boucher and Fragonard.

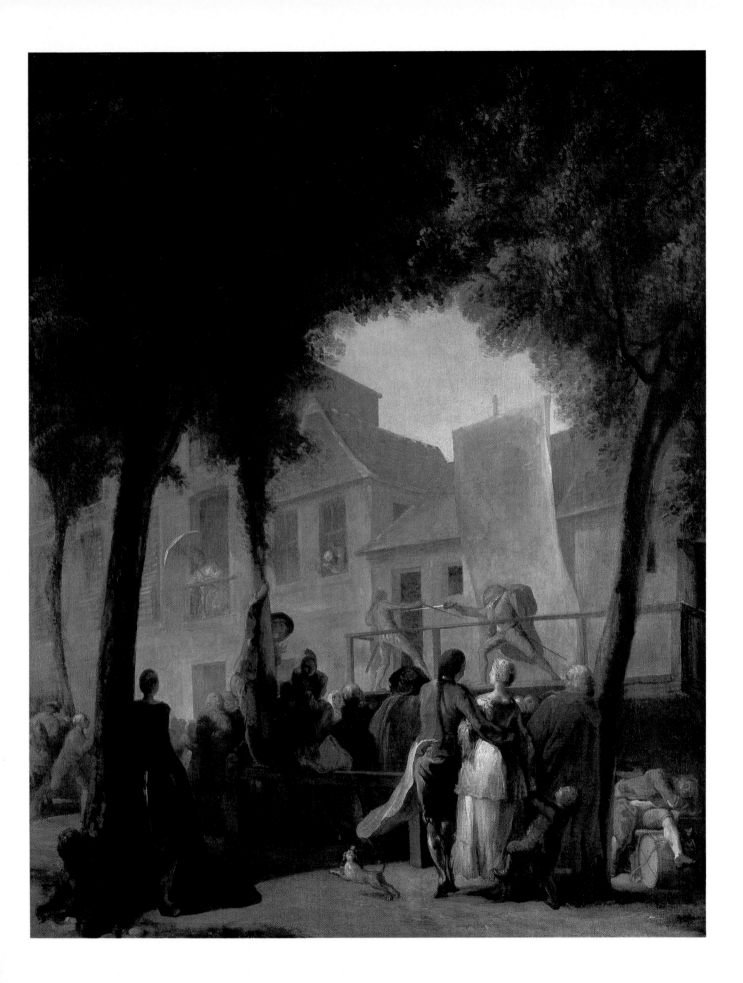

PLATE 48

Claude-Joseph Vernet, 1714–1789

A Sea-Shore (No. 201)

Signed: J. Vernet / f. 1776
Copper, 62 × 85 cm.
Bequeathed by Richard Simmons, 1846/7

Claude-Joseph Vernet was the only French landscape painter of his century to achieve international fame. It was particularly for his seascapes that he became renowned, and these he based on the example of three great precursors of the seventeenth century: Claude, Gaspard Dughet and Salvator Rosa. As for them, Italy played a formative role for Vernet. Born in Avignon, he set out for Rome at the age of twenty, and there settled for almost thirty years. The popularity of Claude, especially with English 'Grand Tourists', may account for Vernet's choice of subject-matter – chiefly coastal or harbour views with ships, lighthouses and luminous skies – and for the fact that he found many English patrons and admirers in Rome. Apparently Richard Wilson was encouraged by Vernet to specialize as a landscape painter, and Joseph Wright of Derby also came under his influence while in Rome.

While Vernet drew upon Claude for his idyllic coastal views, he contrasted these with tempestuous storm scenes, both at sea and inland, in which the dominant influences are Gaspard Dughet and Salvator Rosa. By pairing 'calm' and 'storm' scenes in this way, he was responding to an aesthetic idea, formulated by Burke and popular in the eighteenth century, of the division of landscapes into two categories: the 'beautiful' and the 'sublime'. In his treatment of 'sublime' subjects – in which nature is shown at her most violent – Vernet anticipated the truly romantic landscapes of his successors, de Loutherbourg and Turner.

Nevertheless, Vernet is firmly rooted in the eighteenth century, and, as in this fine, late harbour scene, he brings to his Claudian views picturesque detail and witty observation, which shows the influence of his Italian contemporary, Panini. Although loosely based on the Italian coast near Naples, the scene is probably imaginary. It was in fact painted after Vernet had returned permanently to France. But the fishermen, the peasant women delving among the rocks, and the wealthy tourists are contemporary types. They make a colourful group: an elderly soldier shows off the natural beauties of the scene to two elegant and disdainful ladies – reminiscent of the Don Alfonso, Fiordiligi and Dorabella of Mozart's *Così fan tutte* – while behind them, at a discreet distance, stand the rest of their retinue, including a Turk in a turban – another favourite type of the period, who is also familiar from Mozart's operas.

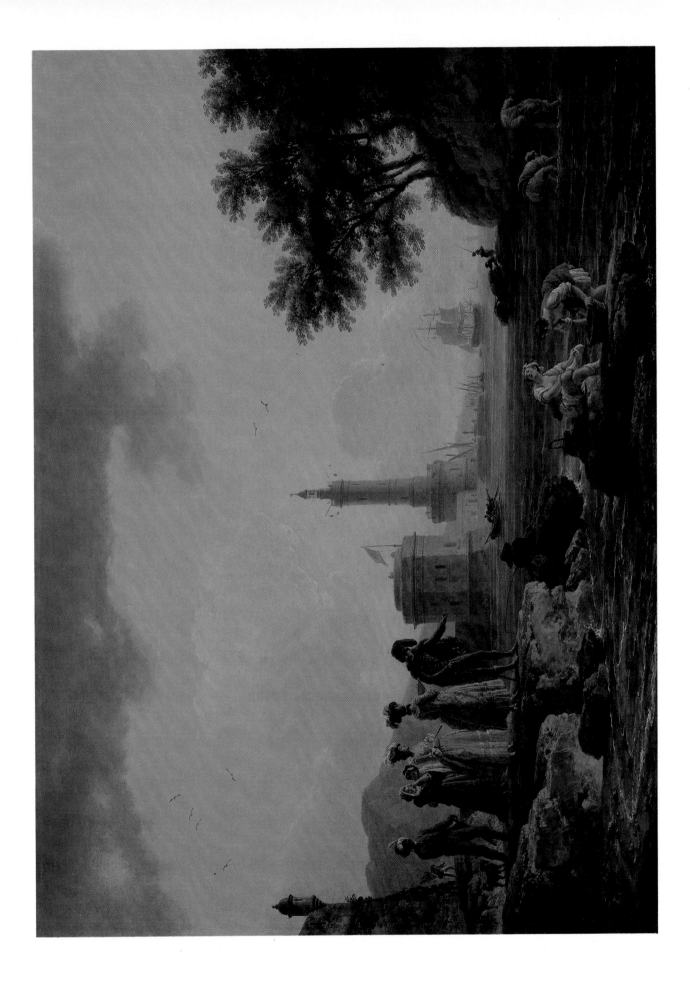

PLATE 49

Elizabeth-Louise Vigée Le Brun, 1755–1842

Self-Portrait in a Straw Hat (No. 1653)

Canvas, 98 × 70.5 cm.
Purchased 1897

During the years preceding the French Revolution in 1789, Madame Vigée Le Brun enjoyed enormous popularity in France, particularly at the court where she painted several portraits of the Queen, Marie-Antoinette, and the royal children. Committed to the monarchy, she went into exile in 1789, and travelled widely in Europe until 1805.

It is not surprising that a woman painter with her particular talent as a portraitist should have risen to such eminence at this time (perhaps to a celebrity not entirely merited by her skills). The period craved simplicity, naturalness and feeling, in portraiture as elsewhere in the arts, qualities associated with womanhood and which Madame Vigée Le Brun, in her often rather sentimental pictures, supplied in abundance. Her royal portraits are intimate, and emphasize the human and – in the case of the Queen, for example – the maternal aspects of the sitter, rather than conventional notions of dignity and authority. At the Salon of 1783 she exhibited a portrait of the Queen, showing her informally attired in a light dress, simple hat and holding a rose, which was severely criticized for its lack of decorum.

The cult of nature and simplicity is well demonstrated in this self-portrait, a replica of a highly popular painting which she executed in Antwerp in 1782 and showed later that year at the Paris Salon. (The signed and dated version is in the Collection of Baron Maurice de Rothschild, Paris.) The painter shows herself, palette and brushes in hand, in the open air, against a cloud-flecked sky, wearing a low-necked dress, and a simple straw hat adorned with flowers. Pretty and youthful, she looks directly at us with a gaze which is candid and unaffected.

The effect of simplicity is, however, entirely calculated. There is nothing spontaneous about this portrait. Claude-Joseph Vernet recommended that Madame Vigée Le Brun should study nature; much in her work, however, is derived from earlier artists, from Rubens, Van Dyck, Domenichino and Guido Reni. This portrait is in fact directly inspired by a painting by Rubens, the famous '*Chapeau de Paille*' portrait which she saw in Antwerp in 1782 and which is today in the National Gallery (No. 852). Although, in comparison with Rubens, Madame Vigée Le Brun is a more naturalistic painter, her self-portrait, for all its charm and freshness, lacks the vitality and natural feeling so abundantly present in Rubens' portrait of Susanna Lunden.

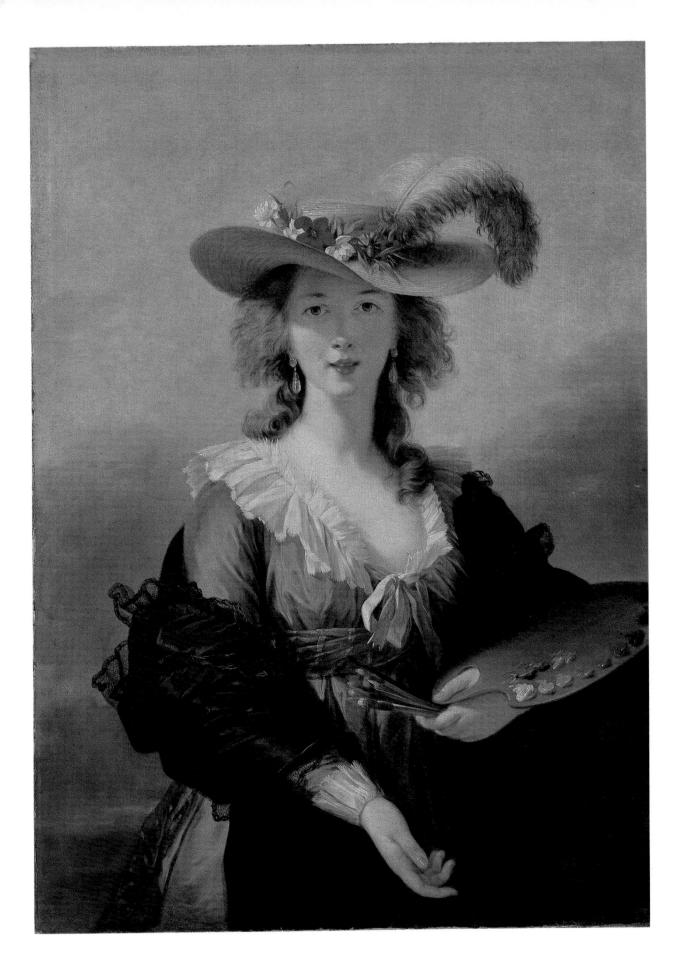

PLATE 50

Jean-Joseph Taillasson, 1745–1809

Virgil reading the Aeneid to Augustus and Octavia (No. 6426)

Signed: Taillasson. 1787
Canvas, 147 × 167 cm.
Purchased 1974

When this painting was exhibited at the Salon of 1787, the *livret,* or catalogue, carried the following explanation of the subject: 'In the description of the Elysian Fields, Virgil has included the praise of Marcellus, dead only a short time, a young hero, the delight of the Empire, son of Octavia, adopted by Augustus. These lines make the greatest impression on the Emperor and on his sister – Octavia faints when the poet pronounces, *"tu Marcellus eris. . . ."* '

The painting shows Taillasson responding to the popular appeal for affecting displays of emotion. Diderot spoke for a generation when he called upon artists to 'make me tremble, weep, shudder; outrage me'. As this desire for moving and serious subjects, usually with a distinct moral bias, arose in reaction to the so-called frivolities of rococo painting, so, in reaction to the informal composition, loose handling and decorative colour of Boucher and Fragonard, artists turned once more to the example of ancient art, interest in which had been reawakened by the excavations in 1748 at Herculaneum and Pompeii. The influential German theorist, Johann Winckle-mann, wrote in praise of the 'noble simplicity' and 'calm grandeur' of Greek and Roman art, and advocated a style that was linear, static and subdued in its colour, in imitation of classical sculpture. Poussin, as an artist whose style had been founded on antique art, was once more adopted as a model by painters, and, in Taillasson's painting, the shallow setting, the interior with its columns and looped curtain, and the frieze-like arrangement of the figures all derive from his work.

The rage for things antique also made subjects from classical history and literature, treated now with archaeological exactitude, increasingly fashionable. The painter who did most to popularize the new neo-classical style in France was Joseph-Marie Vien, Taillasson's teacher, but his insipid works remain rococo in sentiment. Only with the advent of Jacques-Louis David did the neo-classical movement produce outstanding works of art, in which the gravity of style is matched by the seriousness of the patriotic and martial emotion, characteristics which well qualified David to be the painter of the Revolution.

Taillasson's painting is in contrast academic and melodramatic. The subject is well chosen, both for its eminent cast and for its dramatic potential, and the detailed treatment of costume, architecture and furnishing is an indication of the care the artist has taken over archaeological accuracy. But the effort is self-defeating; Taillasson's Romans remain unconvincing in their dumb-show. The most they can manage is a superficial and conventional melodrama, involving the wringing of hands and the raising of eyebrows. Poussin's archaeology may at times have been at fault, but his understanding of human behaviour and heroic emotions was profound. Taillasson trivializes his subject. As the critics of the time observed, Octavia has the colour of a corpse, Augustus manages to ignore entirely her distress, and Virgil, whose face, perversely, is cast in shadow, carries on reading as though nothing has happened.

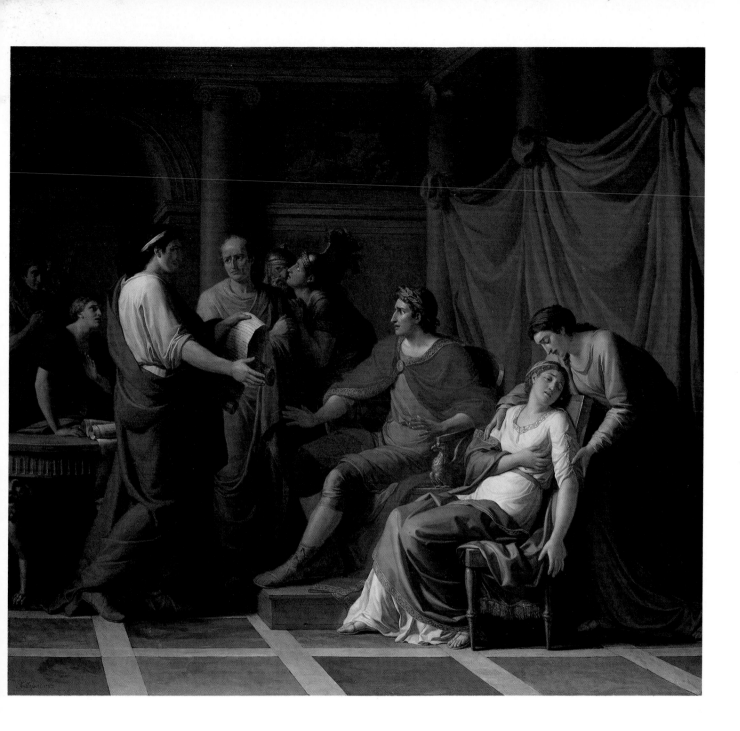

Index to Plates

Note : page numbers throughout refer to the position of the illustrations